IMAGES
of Rail

PHILADELPHIA
RAILROADS

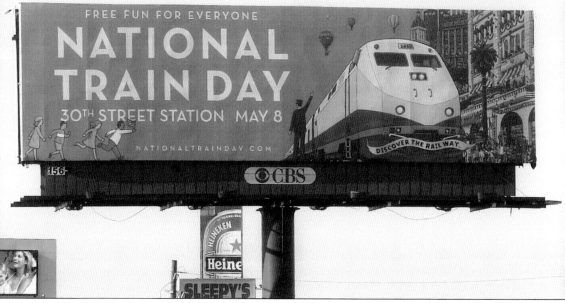

National Train Day started by Amtrak in 2008 to commemorate the completion of the first transcontinental railroad in America on May 10, 1869. Amtrak, the national passenger railway company, sponsors events in major cities with railroad hubs, such as Washington, D.C., Philadelphia, Chicago, and Los Angeles. This billboard, which promotes the event in Philadelphia, was spotted on the exit for the Walt Whitman Bridge on I-95. This event, held on May 8, 2010, kicked off the second-annual celebration at Thirtieth Street Station, a major rail hub in America. (Joel Spivak.)

ON THE COVER: Railroad crews spent a lot of time together, especially on this 1903 Baldwin-built Camelback (Class A 4-0-4-0) switcher locomotive No. 1192 in Philadelphia along the Reading Lines. (Frank Weer.)

IMAGES
of Rail

PHILADELPHIA
RAILROADS

Allen Meyers and Joel Spivak

ARCADIA
PUBLISHING

Published by Arcadia Publishing
Charleston, South Carolina

Printed in the United States of America

Library of Congress Control Number: 2010921603

For all general information, please contact Arcadia Publishing:
Telephone 843-853-2070
Fax 843-853-0044
E-mail sales@arcadiapublishing.com
For customer service and orders:
Toll-Free 1-888-313-2665

Visit us on the Internet at www.arcadiapublishing.com

*A tribute to Oliver Evans, the inventor of the
American "High Pressure Steam Engine"*

CONTENTS

PREFACE

The interest for this book grew from the authors' childhoods in Philadelphia. Joel Spivak grew up 100 yards from the Pennsylvania Railroad's Main Line, where the Forty-second Street trestle crosses the tracks in the Fortieth Street and Girard Avenue neighborhood. Joel spent many hours watching the trains arriving and leaving the city.

After World War II, the Spivak family moved to the West Oak Lane section in the far northern area of the city off Ogontz Avenue. The railroad did not run nearby, but the love of the railroad stayed with Joel.

When Joel was in sixth grade, he transferred to the Logan Demonstration School. He loved to ride the Broad Street Subway by himself every morning. He made new friends, Mark and Stanley, who also loved trains. They watched trains wherever they could find them, and Stanley had a train set in his attic. The exploration and dreaming started there, with hours of running the trains and looking through editions of *National Geographic* for train advertisements. The trio took trips by rail, spending hours just enjoying the ride and each others' company while learning to travel the city.

Because Joel had friends who shared his interest in railroads, his love for trains grew. Wherever you are Mark Waldbaum and Stanley Segal, this book is dedicated to you!

Allen Meyers grew up in North Philadelphia's Strawberry Mansion section until he was eight years old. Allen's dad, Leonard, worked at the U.S. Mint, and sometimes he took his son to his place of work. They traveled on the "A" bus to Spring Garden Street and transferred to the Route 43 trolley car.

The Meyers family migrated to Sears on Roosevelt Boulevard in 1960. The first night in their new house, Allen thought there was an earthquake at 3:00 a.m. on the 5200 block of Pennway Street. It was the early morning Sears freight train rumbling through the darkness behind Allen's house.

Allen and his friends, Jackie Brill and Joe O'Reilly, explored the neighborhood by walking the Pennsylvania Railroad tracks in all directions from Sears. A nature walk on the Friend's Hospital grounds turned up an abandoned set of rails that led to the coal storage area for the power plant, which made electricity and steam for heat in the wintertime. Going north along the tracks above Sears led to the U.S. Navy supply depot, and a right turn took them to Frankford. Allen traveled westward only to Bond Bread, where the tracks then became electrified, once known as Cresecentville station. Traveling south led to Front Street and Erie Avenue, a major railroad junction.

Both Joel and Allen had the pleasure of showing these old haunts to one another while researching this book, and it was pure fun.

INTRODUCTION

The birthplace of America, Philadelphia displayed leadership in the 1830s, less than 50 years after the country's founding, when new modes of transportation were put into operation. Moving around in the early 1800s meant using a horse and wagon or a stagecoach to reach nearby communities. The development of canal companies to plan and build waterways to move products added another component to this era.

Meanwhile, another new method of moving products to market also made its appearance on the scene. The Industrial Revolution, which started in England during this same time period, encouraged the drive for more efficient transportation. The invention of wooden rails, and later iron rails, set down on stones meant that heavier wagonloads pulled by teams of horses could move farther and faster along these railroads.

Many men driven by the prospect to join in the new movement yielded the start of the railroad era. The inventions kept happening in rapid succession. Thomas Leiper constructed the first railroad in America to haul stones from his quarry to market, which was south of Philadelphia. In 1809, he showcased his idea at the Bull's Head Inn tavern in the Northern Liberties District, just north of Philadelphia.

Railroad companies merged with canal companies to transverse the land in Pennsylvania, such as the public works project owned and funded by the Pennsylvania State Legislature. Starting in the late 1820s, the Philadelphia and Columbia Railroad had a grand plan to connect Philadelphia to Pittsburgh via many lines of transportation, which included canals and railroads.

A movement in America to harness steam power for use in transporting passengers and freight took place in Philadelphia during the Industrial Revolution. Raw resources nearby in the way of iron ore from the mountains of Pennsylvania, along with plentiful timber and a growing labor force, allowed the city to become a hub of railroad building in the 1830s, with 12 individual lines.

Matthias Baldwin, a local jeweler, turned his creativity and skills into a new industry by founding the Baldwin Locomotive Works in Philadelphia. The forged metal and applied science all came together when Baldwin created his first steam engine, *Old Ironsides*, in 1831.

The connection of communities several miles from the heart of Philadelphia without teams of horses and wagons meant that the populace could live in the outlying districts with a direct connection to the city for commerce. The first railroad to employ the Baldwin product included the recently chartered Philadelphia, Germantown, and Norristown Railroad line in 1832.

The 1854 consolidation of the city into 27 districts, townships, and boroughs was made easier by the early development of the railroads servicing the new Philadelphia County. After seeking articles of incorporations, and upon the successful sales of stocks to ensure the start of these ventures, railroad lines developed established routes. New methods of burning various fuels, such as wood and hard and soft coal, along with continuous new inventions in riding safety and security, happened right here in Philadelphia. Ocean and land routes south to Baltimore, west to Pittsburgh, and north to New York City gave rise to a very strong economy.

New bridges and tunnels allowed access to Philadelphia from all directions, but new junctions and freight yards created anxious moments for city residents who expanded their residential addresses beyond the original reaches of the railroads. Now some communities were hemmed in by the building of so many tracks. The solutions to these problems took several decades to correct. Elevated structures and embankments moved the dangerous tracks away from adults and children alike. Tunnels for subways made rapid transit in downtown Philadelphia a reality.

The era of applied science and industrial might came together again within 100 years when the railroad industry applied the introduction of electricity to its railroads in the late 1890s. A second revolution soon took place whereby various transportation outlets had to depend on each other for supplies and labor.

The increase in population of Philadelphia and other parts of the nation necessitated a new fuel; therefore, diesel was introduced to the market and was used for powering the many locomotives in the early 1920s. Coal was plentiful, but the struggle to obtain this natural resource as fuel for steam locomotives was shared by city residents who needed it to heat their homes, both of which used vast amounts of hard coal.

Population shifts in Philadelphia dictated the removal of major railroad hubs to various parts of the city in hope of relieving all types of congestion. The building and planning, plus the implementation, went on in most years of the 20th century. In 1932, the U.S. government lent the Pennsylvania Railroad $150 million to upgrade and electrify passenger railroad lines in Philadelphia and the Northeast Corridor.

One hundred years after the start of the railroad industry in Philadelphia came the expansion of automobiles and buses, which competed with the railroads for customers. It was only the start of World War II that extended the life of steam locomotives for another decade.

A railroad renaissance took place in Philadelphia in the 1950s. The Bridge Line from Camden, New Jersey, via the Benjamin Franklin Bridge to Eighth and Market Streets, was extended to Sixteenth and Locust Streets in 1952 through the construction of a tunnel under Locust Street, originally built in 1917. The Broad Street Subway extended to Fern Rock to allow an organized bus loop to ferry riders to destinations in Northwest Philadelphia. The Pennsylvania Railroad demolished its Broad Street Station and the six-block-long "Chinese Wall" (viaduct) from West Philadelphia to city hall, which made Thirtieth Street Station the central address of Philadelphia's railroad hub system. The famous Subway-Surface for trolley cars extended to West Philadelphia under the campuses of Drexel University and the University of Pennsylvania, with portals at Fortieth Street and Woodland Avenue and Thirty-sixth and Chestnut Streets. Thus a unique piece of urban history, with its trolley switching tower at Thirty-second and Market Streets, came to a close. The new Twenty-second Street station of the Subway-Surface, which was located below ground, replaced the Twenty-third Street station. All this occurred in preparation for the Market Street El to go into a subway tunnel that was built in the 1930s. The Market Street El went under the Schuylkill River and rose up to the elevated structure from a portal at Powelton Avenue and Market Street, with its first elevated stop then at Forty-sixth Street. With all this construction in the 1950s, University City took on a whole new image.

The effect on the changing landscape of Philadelphia is a subject unknown. But rather it is found fragmented in articles, books, and journals. Over 190 different railroads, companies, and lines existed in Philadelphia and its nearby suburbs from 1830 to 1930. *Philadelphia Railroads* seeks to give the reading public a visual history and outline of this great aspect of the city's history. All the railroads listed in this book in parenthesis are their charter incorporation dates.

One

EARLY HISTORY

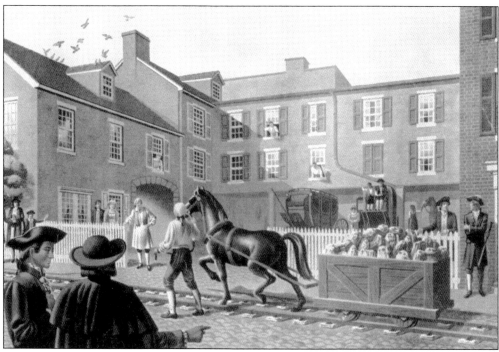

The experiment of a railroad in America began in Philadelphia with the demonstration of a railroad in front of the Bull's Head Inn in the Northern Liberties District at Second and Poplar Streets in 1809 by quarry owner Thomas Leiper. A request for a canal to be dug out from the Crum Creek to Ridley Creek had been denied by the State of Pennsylvania, so Leiper built his own means to haul stone from the quarry. This was the first permanent railroad built in America. (Nether Providence Historical Society.)

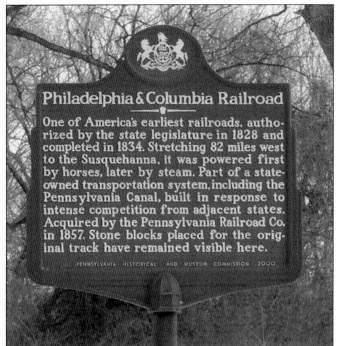

This historic marker on Edgeley Avenue off Belmont Avenue explains the early history of the Philadelphia and Columbia Railroad system (1828). The marker was placed in Fairmount Park by the State of Pennsylvania and dedicated on May 17, 2001. (Allen Meyers and Joel Spivak.)

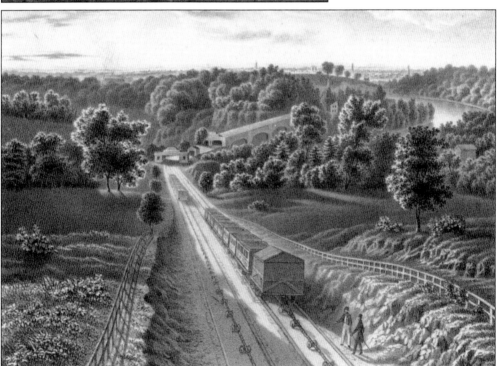

Access to points west on the Philadelphia and Columbia Railroad meant taking a ferry across the Schuylkill River and loading cars with freight and passengers. Physical barriers such as high terrains were crossed with the help the Belmont Plane, a 187-foot incline that originally had pulleys and ropes attached to a steam engine to haul the valuable cargo on its way westward. (Chuck Denlinger.)

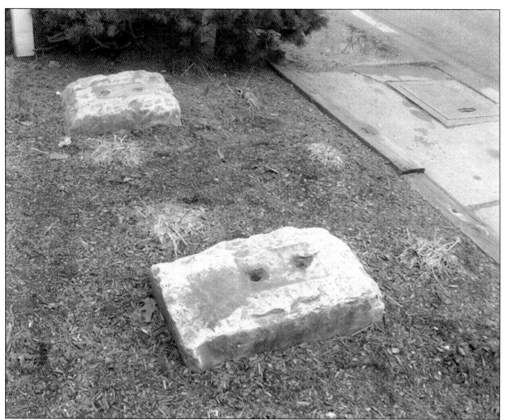

These stone railroad blocks used to hold the rails were recovered a few years ago on the grounds of the Whitehall station (now used as the Bryn Mawr Hospital Thrift Shop) along the original Main Line portion of the Philadelphia and Columbia Railroad. (Joel Spivak.)

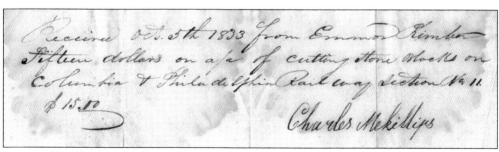

Presented by Charles Mekillips to Emmos Kimber, this receipt in the amount of $15 was received on October 5, 1833, for stone cutting in section No. 11 of the Philadelphia and Columbia Railroad. (Chuck Denlinger.)

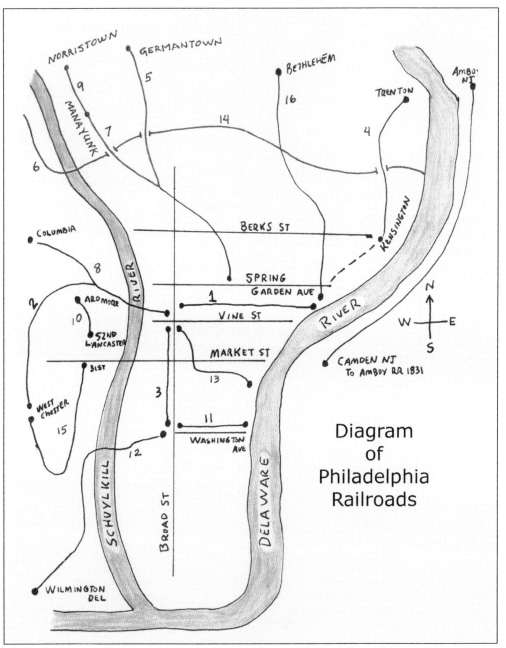

Starting in the 1830s, the opening dates of the railroads were as follows: (1.) Northern Liberties and Penn Township Railroad, 1831; (2.) West Chester Railroad, 1831; (3.) City Railroad, 1832; (4.) Philadelphia and Trenton, 1832; (5.) Philadelphia and Germantown Railroad, 1832; (6.) Philadelphia and Reading Railroad, 1833; (7.) Philadelphia and Germantown Railroad (to Manayunk), 1834; (8.) Philadelphia and Columbia Railroad, 1834; (9.) Philadelphia, Germantown, and Norristown Railroad, 1835; (10.) West Philadelphia Railroad, 1835; (11.) Southwark Railroad, 1835; (12.) Philadelphia, Wilmington, and Baltimore Railroad, 1836; (13.) Eastern Extension (City Railroad), 1837; (14.) Richmond Branch Railroad, 1842; (15.) West Chester and Philadelphia Railroad, 1848; (16.) North Pennsylvania Railroad, 1858. (Allen Meyers.)

William Robinson appreciated and sought out the opportunity to promote his own business, while at the same time providing an invaluable service to riders, informing them of the daily train schedule. (Chuck Denlinger.)

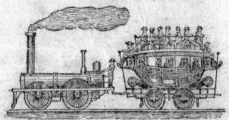

First Rapid Transit Train in Penna.

Drawn by the First Locomotive built in the U. S.

Compliments of WM. ROBINSON,

MERCHANT TAILOR,

And Dealer in Clothing & Furnishing Goods.

4017 Germantown Avenue, Nicetown.

PHILADELPHIA, GERMANTOWN AND NORRISTOWN RAIL-ROAD.

LOCOMOTIVE ENGINE.

NOTICE.—The Locomotive Engine, built by M. W. Baldwin, of this city,) will depart DAILY, when the weather is fair, with a TRAIN OF PASSENGER CARS, commencing on Monday the 26th inst., at the following hours, viz:—

FROM PHILADELPHIA.	FROM GERMANTOWN.
At 11 o'clock, A. M.	At 12 o'clock, M.
" 1 o'clock, P. M.	" 2 o'clock, P. M.
" 3 o'clock, P. M.	" 4 o'clock, P. M.

The Cars drawn by horses, will also depart as usual, from Philadelphia at 9 o'clock, A. M., and from Germantown at 10 o'clock, A. M., and at the above mentioned hours when the weather is not fair.

The points of starting, are from the Depot, at the corner of Green and Ninth street, Philadelphia; and from the Main street near the centre of Germantown. Whole Cars can be taken. Tickets, 25 cents. nov 24-3t —From American Daily Advertiser, Nov. 24, 1832.

LOOK ON THE OTHER SIDE.

The Philadelphia and Germantown Railroad (1831) left its depot at Ninth and Green Streets traveling northwesterly toward Germantown, which was some 6 miles away. The steam locomotive *Old Ironsides* was built by Matthias Baldwin only six blocks away. (Free Library of Philadelphia.)

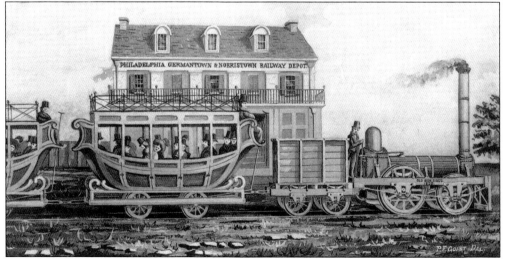

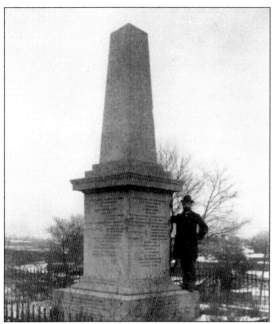

The Newkirk Monument honors the work of four railroads: the Philadelphia, Wilmington, and Baltimore (1836); the Wilmington and Susquehanna; the Baltimore and Port Deposit; and the Delaware and Maryland. These railroads started construction on July 4, 1835, with the goal of making a continuous connection from Baltimore to Philadelphia. The Newkirk Viaduct, known as the Gray's Ferry Bridge, carried both the railroad and foot traffic across the Schuylkill River into Philadelphia from the southwest direction. It is now located adjacent to the tracks at Forty-ninth Street above Lindbergh Boulevard. (Frank Weer.)

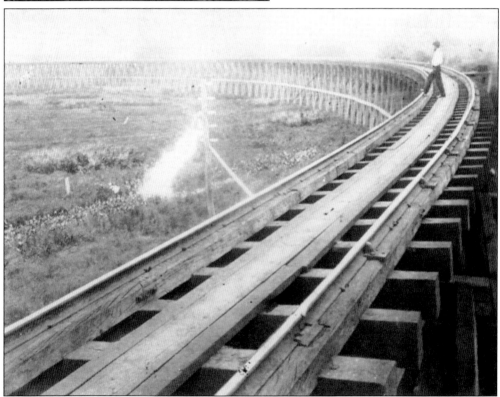

Marshy ground on the west side of the Schuylkill River necessitated the building of this wooden railroad trestle in the 1860s to service the Delaware Extension Railroad (1862) near Gray's Ferry. The word "trestle" was adopted from Roman times with its familiar legs or piers holding up a crossbeam. (Chuck Denlinger.)

14

Bought by the Philadelphia, Germantown, and Norristown Railroad in 1836 to haul soapstone from a quarry 1 mile north of the Shawmont station, a short distance past Manayunk, this Campbell Company–built locomotive was its first eight-wheel engine. (John Johnstone.)

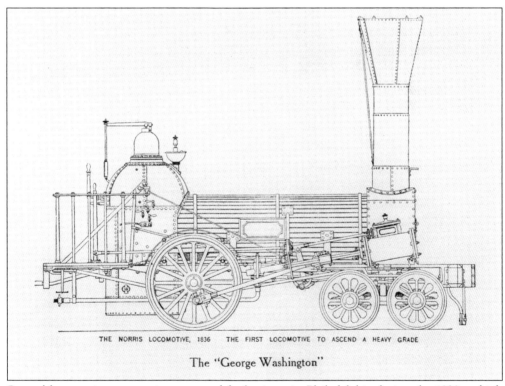

THE NORRIS LOCOMOTIVE, 1836 THE FIRST LOCOMOTIVE TO ASCEND A HEAVY GRADE

The "George Washington"

Several locomotive companies competed for business in Philadelphia during the 1830s, which included the Baldwin Locomotive Works at Broad and Hamilton Streets and Eastwick and Garrett at Twelfth and Willow Streets. The Norris Locomotive Works at Seventeenth and Hamilton Streets manufactured the *George Washington*, which was the first to conquer the steep Belmont Plane in 1836. (Delaware County Historical Society, Pennsylvania.)

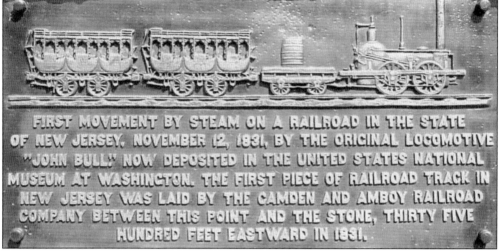

FIRST MOVEMENT BY STEAM ON A RAILROAD IN THE STATE OF NEW JERSEY, NOVEMBER 12, 1831, BY THE ORIGINAL LOCOMOTIVE "JOHN BULL" NOW DEPOSITED IN THE UNITED STATES NATIONAL MUSEUM AT WASHINGTON. THE FIRST PIECE OF RAILROAD TRACK IN NEW JERSEY WAS LAID BY THE CAMDEN AND AMBOY RAILROAD COMPANY BETWEEN THIS POINT AND THE STONE, THIRTY FIVE HUNDRED FEET EASTWARD IN 1831.

This bronze plaque adorns the Camden and Amboy Monument, erected by the Pennsylvania Railroad and dedicated on November 12, 1891, to mark the 60th anniversary of its first run. The plaque is located at Farnsworth and Railroad Avenues in Bordentown, New Jersey. (Joel Spivak.)

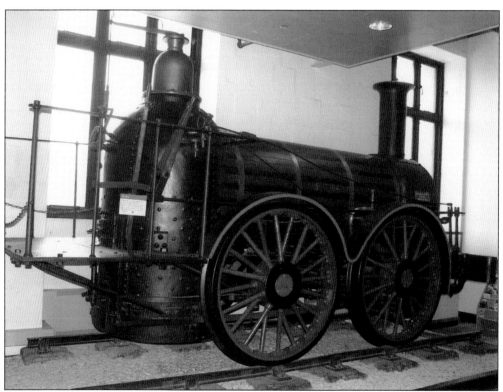

The finest and most powerful locomotive owned by the Philadelphia and Reading Railroad, the *Rocket* was imported from England in 1838 and is now on display at the Ben Franklin Institute. The museum had a number of railroad executives who saw the need to preserve the past. The *Rocket* was brought to the Franklin Institute on October 17, 1933. (Joel Spivak.)

The West Philadelphia Railroad Company started in 1835. This railroad sought a more level route westward to Ardmore, thus avoiding the Belmont Plane. In 1850, the Pennsylvania Railroad (1846) bought out the West Philadelphia Railroad and formally extended it to the Market Street Permanent Bridge from Fifty-second Street and Lancaster Avenue. (Chuck Denlinger.)

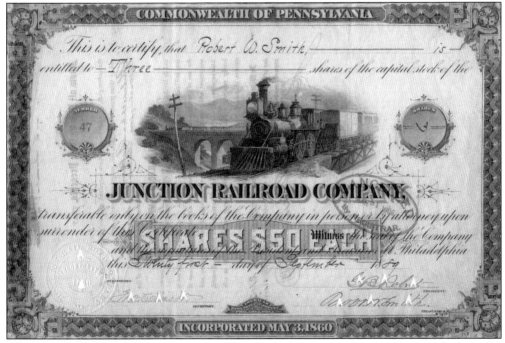

The sale of stocks to interested parties and individuals who sought to make a profit from the creation of a specific entity allowed the railroads to build and open lines once a specific, agreed-upon amount of backup capitol was raised. The Junction Railroad (1860) ran from the Reading's Belmont station on the west side of the Schuylkill River southward to the newly planned Arsenal Railroad Bridge 4 miles away. (Chuck Denlinger.)

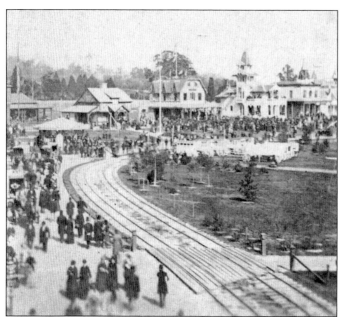

America's 100th anniversary celebration took place in Philadelphia in 1876. The huge leap in industrial expansion and new inventions turned Fairmount Park, west of the newly built Philadelphia Zoo, into a transportation hub all in itself. The crowds came by steamboats and trains from around the country to participate in viewing many exhibits of modern marvels from around the world. (Free Library of Philadelphia.)

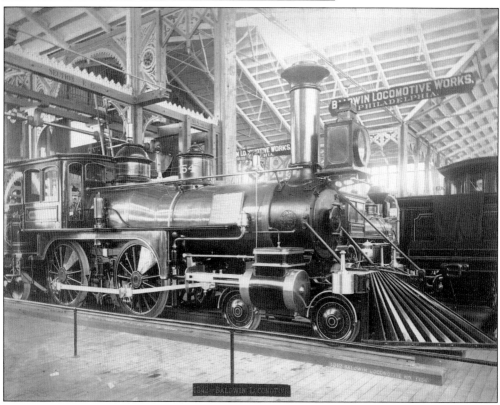

Of course Philadelphia, "The Work Shop of the World," had many items of interest on display. Locomotive No. 1154, built by the Baldwin Locomotive Works, was on display inside Machinery Hall. A horsecar brought attendees from the Thirty-second and Market Street station to the centennial grounds at Belmont and Parkside Avenues. (Free Library of Philadelphia.)

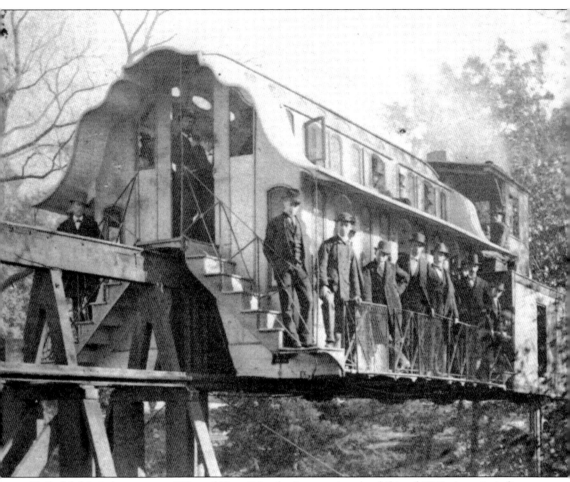

Philadelphia is known as a "City of Firsts." In the international exhibit of 1876, America's first monorail was introduced as the "Single Railroad," which rose above the Belmont Ravine in Fairmount Park on the centennial grounds. The educational and recreation aspects of this machine made it an instant hit and a great ride. (Free Library of Philadelphia.)

The Pennsylvania Railroad (1846) acquired the publicly funded and state controlled Philadelphia and Columbia Railroad in 1857. Railroad executive Alexander Cassatt promoted a portion of the railroad as the "Main Line" and recommended station name changes, which were also adopted by the villages to sound more appealing. Such names were Bryn Mawr and Ardmore. (Chuck Denlinger.)

The franchise of railroads spread across America, and Philadelphians enjoyed the opening of the Jersey Shore with lines to Atlantic City, known as the "Lungs of Philadelphia" in the summertime before air-conditioning was invented. The Pennsylvania and Reading lines had no problem attracting customers and even created the Ferry Line to shuttle "pleasure seekers" from Philadelphia to Camden, to catch their trains. (Chuck Denlinger.)

Two

THE CHANGING
LANDSCAPE

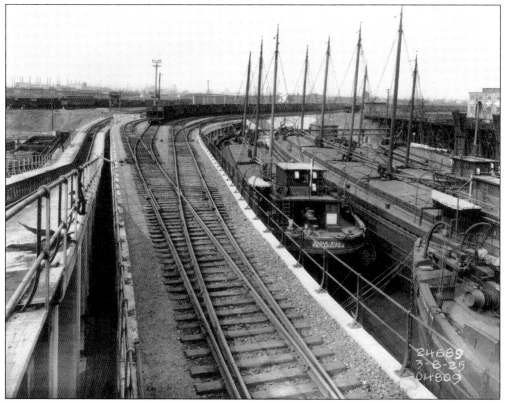

As the railroads and Philadelphia began to grow, William Penn's "Green Town" began to change. While railroads made it easy to get around the area, industrial building on streets adjacent to the railroads bedded down many city streets, which became clogged with railroad tracks. Above is a depiction of the combination of canal companies with the Reading Railroad coal division (Richmond Branch 1836) along the Delaware River at the end of the coal line, which snaked across North Philadelphia to Port Richmond. Here the tugboat *Eagle Hill*, a three-mast "sea barge," is docked at Pier No. 18. (Frank Weer.)

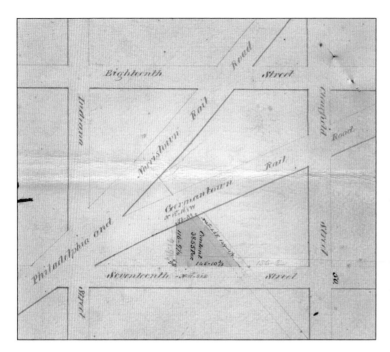

The map of Philadelphia changed drastically in the 1830s with the placement of many railroad tracks throughout North Philadelphia, especially at Sixteenth and Indiana Streets, where the Philadelphia, Germantown, and Norristown Railroad lines split northwest toward Manayunk and to the northeast for Germantown, thus creating the famous Sixteenth Street Junction. (Chuck Denlinger.)

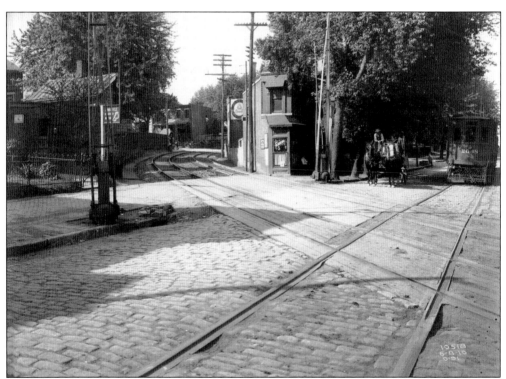

In the last decade of the 19th century, the new electric streetcar lines in the city encroached upon the railroad. In the Germantown section, on Chelten and Bayton Avenues, the Philadelphia and Reading Railroad crosses the trolley car tracks at grade level. (Frank Weer.)

At the corner of Ninth and Poplar Streets, only a few blocks north of the terminal on Ninth and Green Streets, stood a general store that dispensed modern-day "cut rates" or various sundries. The local residents were protected from the passing trains by a watchman who stopped traffic to allow trains the right of way. (Frank Weer.)

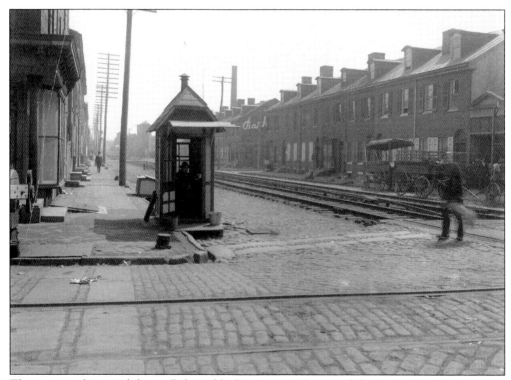

The streetcar lines with heavy Belgian-block pavements improved the streets in certain areas of Philadelphia, yet the local residents were hemmed in by the railroad tracks right outside their front door, running down the middle of the street. (Frank Weer.)

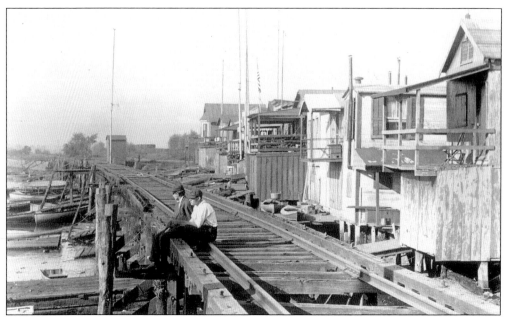

The Kensington and Tacony Railroad (1861) served the businesses along the piers and bulkheads adjacent to the Delaware River. This photograph of the northeast section of Philadelphia included Bridesburg, near Bridge Street. The railroad helped to create borders of Philadelphia's districts only serviceable by rails. (Bridesburg Historical Society.)

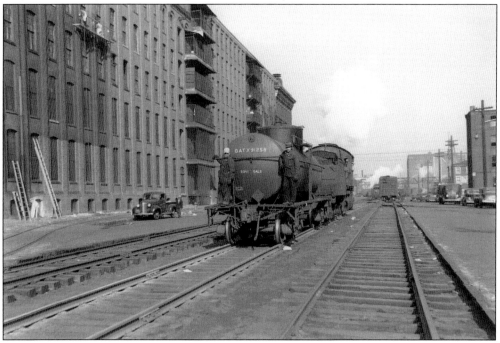

Dating back to when it was formed for easy access to the piers and wharves along the Delaware River, the width of Delaware Avenue measured more than 100 feet in some spots. Some locations had five or six tracks to accommodate heavy freight traffic on Delaware Avenue. This photograph was taken at Spring Garden Street in the 1940s. (Frank Weer.)

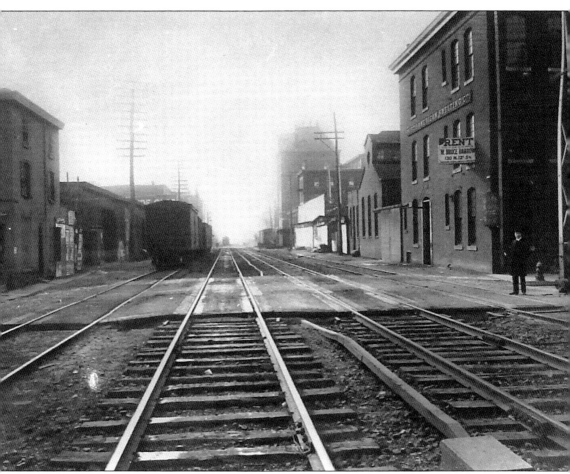

The boundary lines of the old townships and districts in the 1830s were perfect for laying track beds, since they were largely open spaces. After the railroad laid their tracks, factories and warehouses sprung up on the sides of these streets, as in this 1906 photograph of Ninth and Thompson Streets. (Philadelphia City Archives.)

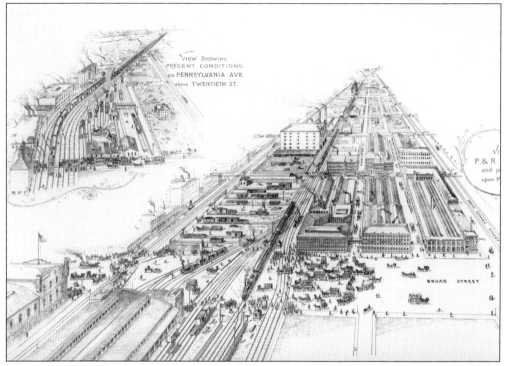

The proposal for the first subway in Philadelphia took shape along the original bed of the Philadelphia Canal, which connected the Schuylkill and Delaware Rivers. Instead, the City Branch of the Philadelphia and Reading Railroad in the 1890s found it necessary to tunnel under busy North Broad Street where there was originally a 16-track grade crossing. (Free Library of Philadelphia.)

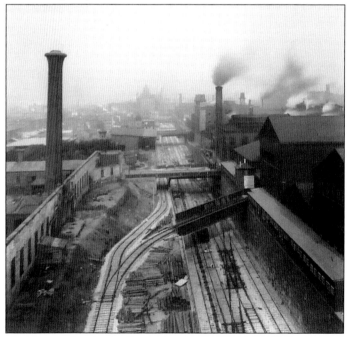

The Pennsylvania Avenue Subway was built as an open-trench project below ground level to alleviate the many grade crossings and give access to the huge Baldwin and Norris Locomotive Works. This city-sponsored work also created the first "subway expressway" in Philadelphia through the elimination of many grade crossings. (Philadelphia City Archives.)

Many tons of dirt was excavated during the construction of the Pennsylvania Avenue Subway. The invention of the steam shovel, patented by William Otis (1839), in addition to heavy manual labor, aided in the process of removing large chunks of rock and dirt at this Sixteenth Street work site in 1893. (Philadelphia City Archives.)

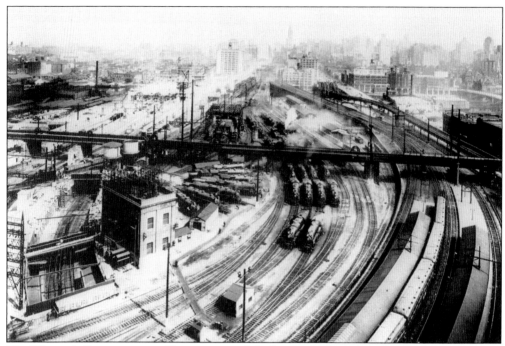

The Thirtieth Street train yard became one of the largest in the nation during the early 1900s. The accumulation of a dozen or so tracks made the area a very busy place for through traffic. The separation of the freight traffic from the passenger traffic spilled over to the designation of the engine house (north of Market Street), which was where seven or eight locomotives entered the turntable in preparation for reassignment. (Philadelphia City Archives.)

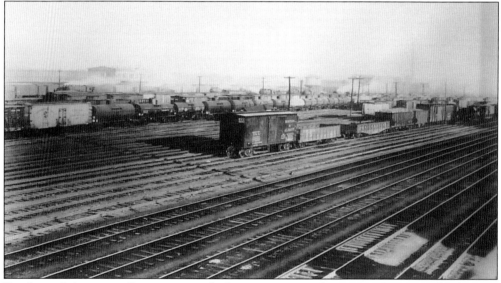

Freight yards became collection points for boxcar storage and active yards to assemble boxcars into trains. The order and placement of the cars reflected where on the line certain cars could be uncoupled and sent to specific private sidings from one of Philadelphia's largest yards in West Philadelphia at the Fifty-second Street and Lancaster-Columbia Avenue Junction (1900). (Philadelphia City Archives.)

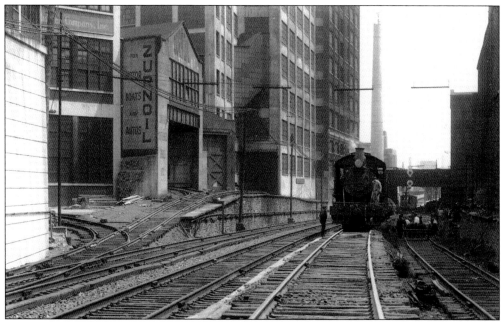

Philadelphia grew its industrial complex of warehouses and factories in all parts of the city. The group of buildings at left in this photograph once housed the Botany 500 men's clothing factory, which was located at Broad Street and Lehigh Avenue in North Philadelphia. Ramps were built to access the buildings and factories and for easy loading. (Frank Weer.)

In the 1890s, before the Pennsylvania Avenue Subway became a reality, this freight yard existed off Eighteenth Street, which was to the side of the main line. Storage of empty boxcars, ready for daily operations, filled areas of ground that were once occupied only by woods. (Philadelphia City Archives.)

In this 1911 photograph, hard manual labor took place below these extremely long train sheds that housed the Green Street Engine House. The tall building, located just left of the shed, served as the Reading Railroad office of the former Philadelphia, Germantown, and Norristown Railroad. (Frank Weer.)

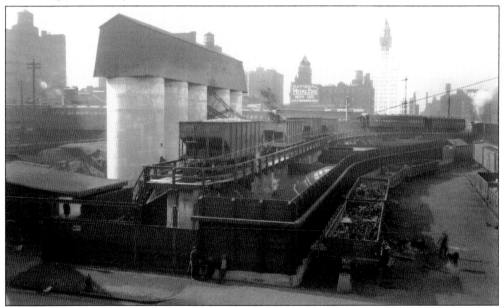

Sometimes this great 1930 photograph needs to be viewed more than once to really see what is pictured. Looking past the coal-loading operation of the boxcars, a passenger train of the Pennsylvania Avenue Subway is visible at Broad Street heading across the Thirteenth Street Bridge to the viaduct and then to the downtown Reading Terminal. (Frank Weer.)

Philadelphia's first water tower, located at Tenth and Diamond Streets, was a monstrous piece of railroad infrastructure. The tower allowed for the fast delivery of water for the internal workings of the steam locomotives via a swing-arm mechanism. (Frank Weer.)

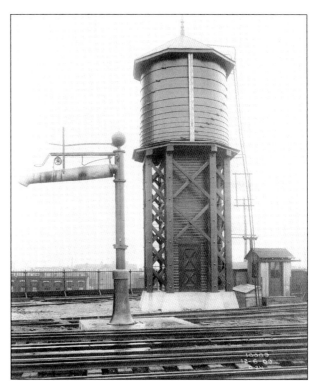

Heavy locomotives chugged down from the Reading area and pulled long trains of 100 cars filled with coal. The Richmond Branch (1836) allowed train traffic direct access to the Delaware River wharves for oceangoing vessels. This locomotive, with its short smokestacks, passed under the Frankford Elevated Trestle near the Coral Street station and Richmond Junction, in the early 1920s. (Frank Weer.)

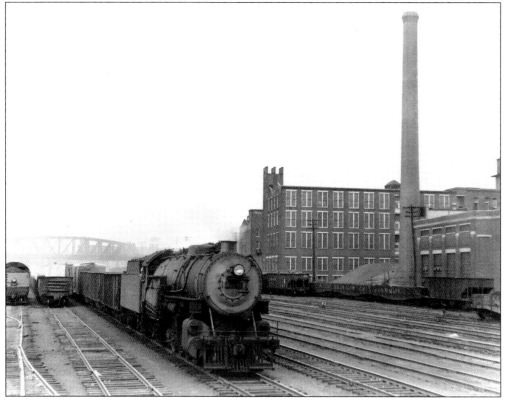

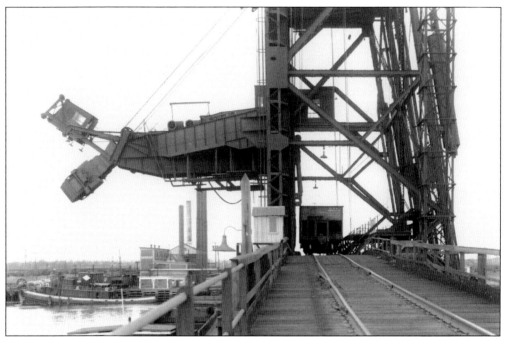

During World War I, more steel went up as bridges and cranes were constructed along the Delaware River to assist in the relentless process of providing fuel to an energy-hungry America. The "mylar" coal dumper inverted individual cars into waiting ship hulls north of the Cramps Shipyard near York Street. (Frank Weer.)

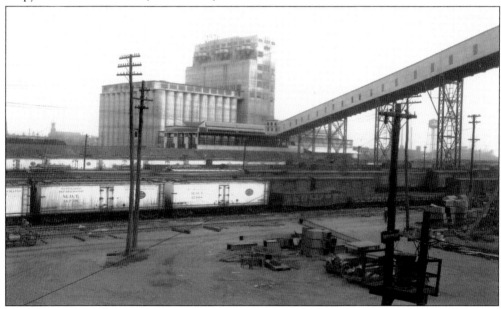

Philadelphia's Belt Line Railroad (1889) extended southward from Tacony along the contour of the Delaware River. Rounding the "horn of South Philadelphia" and going through the Philadelphia Naval Shipyard to Girard Point, the Belt Line Railroad headed up the Schuylkill River to service the grain elevators and collect premier yellow-clay bricks from several brickyards near Spruce Street. The icehouses received their loads in refrigerated cars from ice harvesters. (Frank Weer.)

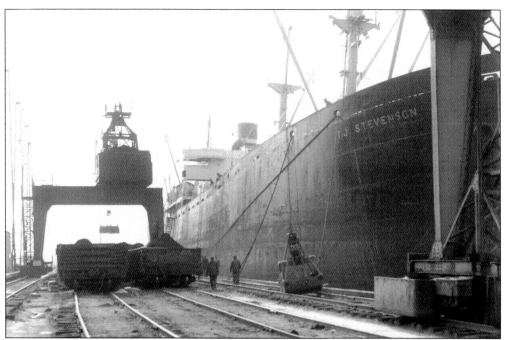

Another Philadelphia silhouette was created by huge mechanical port-side cranes that could lift many tons of scrap metal from gondola cars onto waiting ships, which would transport the material on the Delaware River to processing plants that made World War II supplies. Philadelphia's scrap-metal yards were plentiful along the railroads, especially along Delaware Avenue. (Frank Weer.)

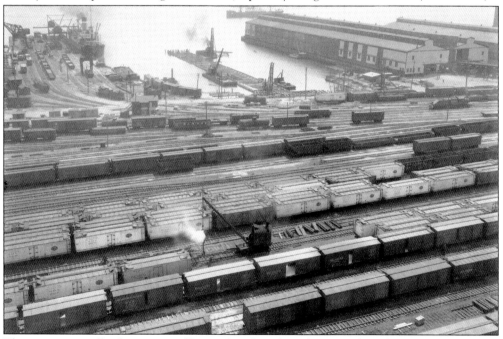

The vast expanse of land once covered by woods and marshes adjacent to the Delaware River were steam bulldozed and back filled for massive track beds of railroads, evident in this 1926 photograph, to serve the many piers around the Tioga Marine Terminal, north of Allegheny Avenue. (Frank Weer.)

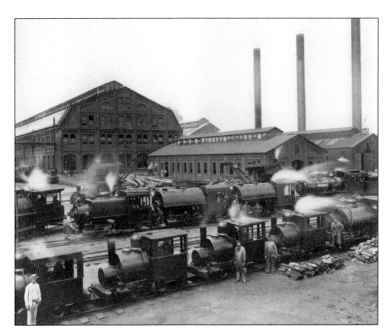

Busy freight yards operated six days a week shuffling cars and trains in Philadelphia. The Baldwin Locomotive Works built miniature locomotives for this purpose, and it seemed like a familiar Lionel G gauge train set at the Midvale Steel plant. The Midvale Branch Railroad (1884) served an extensive industrial corridor north of Hunting Park Avenue in the Nicetown section. (Free Library of Philadelphia.)

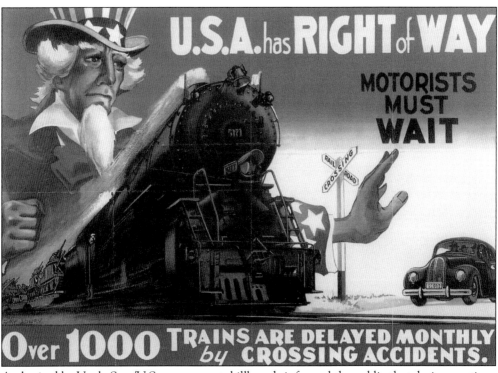

Authorized by Uncle Sam/U.S. government, billboards informed the public that during wartime, "trains had the right of way." Automobiles challenged the trains at many grade crossings in and around Philadelphia, which resulted in many accidents and delays in the war effort. (Joel Spivak.)

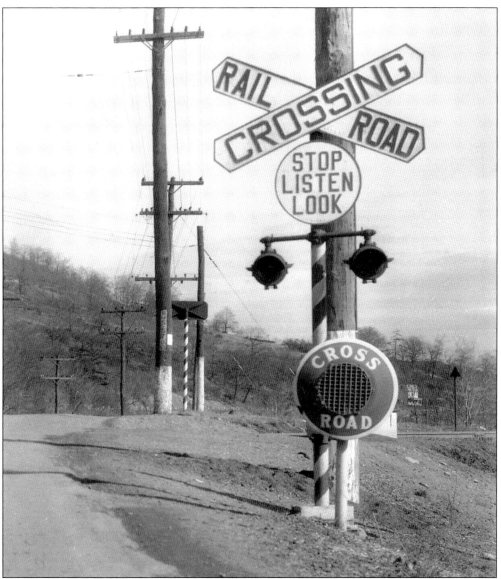

Another familiar piece of the American landscape that many take for granted had its genesis with the Reading Railroad. The signpost at grade crossings with the cautionary words "Stop, Look, Listen" was adopted by a superintendent who heard Pennsylvania Supreme Court Justice Edward Paxan rule in an 1892 case with those exact words. The Reading Railroad added flashing lights for an extra measure of safety. The signpost was adopted by the entire railroad industry. (Frank Weer.)

Construction of enhanced railroad right-of-ways took place on the Reading Railroad in this mid-1890s photograph. The Ninth Street Line rises above Spring Garden Street in preparation for meeting the City Branch Line from Pennsylvania Avenue, with a viaduct in the general area, before heading to its new Reading Terminal at Twelfth and Market Streets. The engine house is off to the side. (Frank Weer.)

Urban railroad exploration by both Spivak and Meyers yielded this portion of the Reading Railroad Viaduct, which was built in the 1890s, near Twelfth Street and Ridge Avenue. The viaduct was expanded from two to four tracks in 1912, and the railroad was electrified in the 1920s. It is currently abandoned. (Allen Meyers and Joel Spivak.)

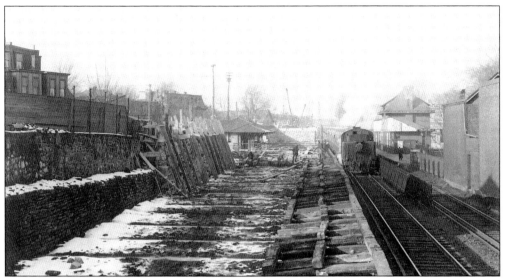

The original line of the Philadelphia, Germantown, and Norristown Railroad, acquired by the Reading Railroad in 1870, ran through Tioga. The heart of this residential district had trains passing through at grade level until the railroad became elevated above street level in the 1910s. (Frank Weer.)

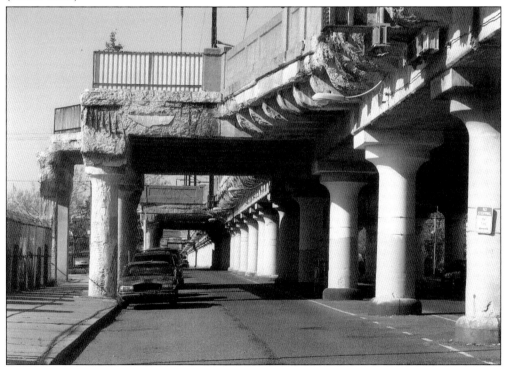

The original Powelton-Philadelphia Railroad (1856) ran southward on the west bank of the Schuylkill River past Market Street. It crossed the Schuylkill River at the Arsenal Railroad Bridge on its way to the Philadelphia Gas Works, in the Point Breeze section of South Philadelphia, along Twenty-fifth Street. The Twenty-fifth Street Viaduct was constructed in the 1920s with beautiful Romanesque columns as supports and is still active in 2010. (Joel Spivak.)

The Easton Road grade crossing in Glenside, only several miles over the northwest border of Philadelphia, existed where the North Pennsylvania Railroad (1852) made a connection with the Northeast Pennsylvania Railroad (1870) farther up the line. The grade crossing became very heavily traveled and dangerous and eventually became subject to a possible grade separation of commercial traffic from the railroad. (Frank Weer.)

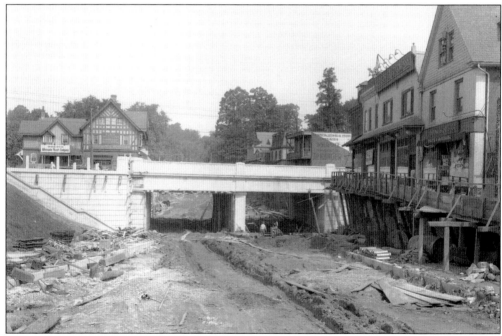

The demolition process in the early 1920s was long and arduous. The train still had to run safely over whatever solution was implemented. The concrete treatment for the entire bridge made this look like an easy project. The houses and businesses were accessed by wooden walkways with large timber supports, as seen in this 1928 photograph. (Frank Weer.)

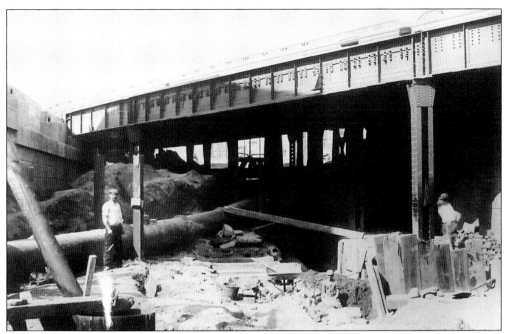

The period from the 1890s until the 1930s, when grade separation work took place, created a new group of industrial steel workers, skilled craftsmen, and engineers to raise or lower the street level the railroad right-of-ways were on. Industries all around the construction sites were affected, including the famous Bayuk Cigar manufacturer that produced Phillies cigars. The company hired cabs to get their workers around the construction area at Ninth Street and Columbia Avenue. (Free Library of Philadelphia.)

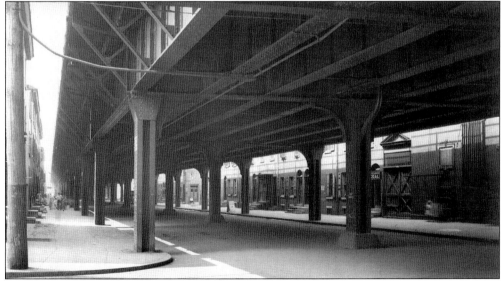

The cost of grade separation took on a whole new meaning for residential areas, as they originally had an active railroad in the middle of the street. Now the neighborhoods were divided by impressive steel super structures, which were perfected and could double today as our finest interstate highway overpasses. The Ninth Street Reading Railroad Viaduct runs from Poplar Street to Jefferson Street in 1910. (Frank Weer.)

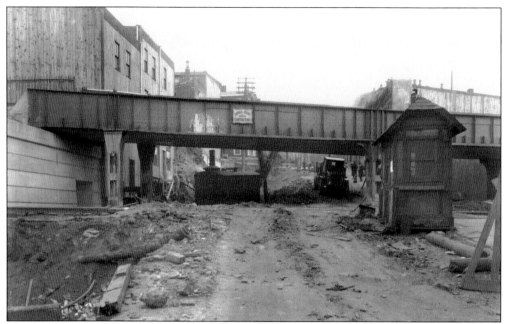

Three railroads ran through Manayunk at one time. The "Pennsy" (Pennsylvania Railroad) ran one line from West Philadelphia to Manayunk to Norristown. The Reading Railroad ran two lines, one of which was a freight line, on the west side the Schuylkill River past Manayunk to the coal regions. The Cresson Street Viaduct, with its mixed use of steel elevated structures along with earthen embankments, crossed Green Lane in 1930. (Frank Weer.)

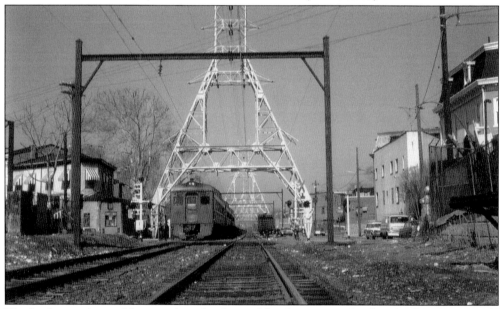

The landscape changed forever when the demand for electricity and railroad right-of-ways could be useful for distribution routes. The high-tension voltage lines ran above the railroad with wires strung on large steel erector-set structures called "over builts." The unfinished grade-crossing project ran out of money in the 1930s, and the Indian Queen Lane is still a grade crossing in East Falls. (Frank Weer.)

Three

PHILADELPHIA BUILT

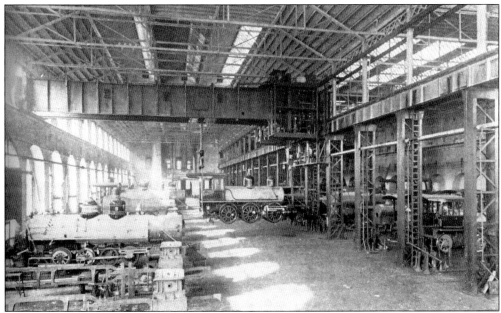

Philadelphia played a crucial role in the expansion of the railroad industry. Components for the railroad were all manufactured, tested, and utilized here in Philadelphia. Innovations helped the railroad industry expand and grow, and eventually many products were then exported. The Norris Locomotive Works joined the Baldwin Locomotive Works, along with Eastwick and Garrett (Twelfth and Willow Streets) and the J. G. Brill Company in Southwest Philadelphia, in the same area of producing locomotives. Many locomotives are being assembled at the Norris Works, seen here around 1875. (Philadelphia City Archives.)

The Baldwin Locomotive Works at Broad and Hamilton Streets in Philadelphia, founded by former-jeweler Matthias Baldwin, turned into an American institution. The city of Philadelphia grew out to the major industrial complexes within a 20-year period. The Spring Garden District, which was where the plants were located, was incorporated into Philadelphia County and City in 1854. (Chuck Denlinger.)

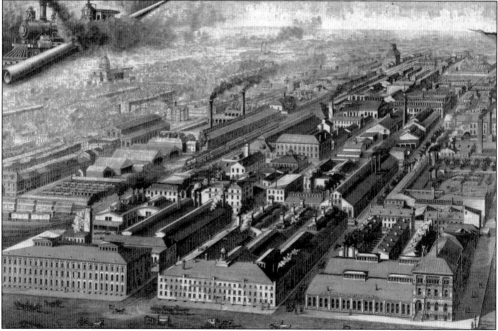

The spawning Baldwin Locomotive Works situated west of Broad Street was home to tens of buildings, factories, and testing grounds. The fuel for the factories came from upstate on freight cars that brought the anthracite coal from the northern part of Pennsylvania. The orders for steam locomotives never seemed to stop until the 1930s and still lingered for another 20 years. (Chuck Denlinger.)

The Baldwin Locomotive Works at Eighteenth and Hamilton Streets spawned a large number of cottage industries to supply parts and innovative products that premier train builders could utilize in their final product. W. M. Sellers and Company opened shop in this rich work environment and had a great reputation in making the engine turntables so that locomotives could quickly switch to another track. (Joel Spivak.)

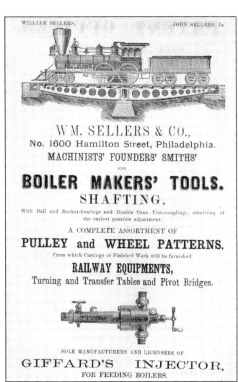

From its main offices at Twenty-fifth and Hamilton Streets in the Spring Garden district, the Kimball and Gorton Philadelphia Railroad Car Manufactory advertised its products in many trade magazines throughout the country. After the Civil War, the railroad cars mounted on double-truck assemblies could seat 40 passengers. (Joel Spivak.)

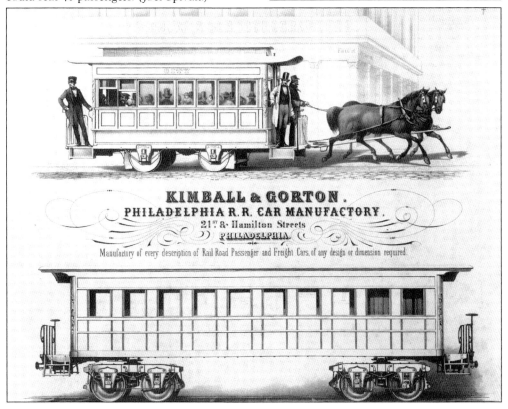

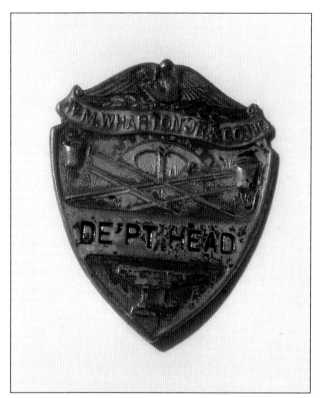

The William Wharton Jr. and Company at Twenty-fifth Street and Washington Avenue in South Philadelphia specialized in the manufacturing of railroad switches, crossings, and "frogs." The badge pictured at left was worn by a distinguished worker known as the department head, which is declared on the badge. The intricate details of the badge include a crossover setup and the "gears of industry." (Joel Spivak.)

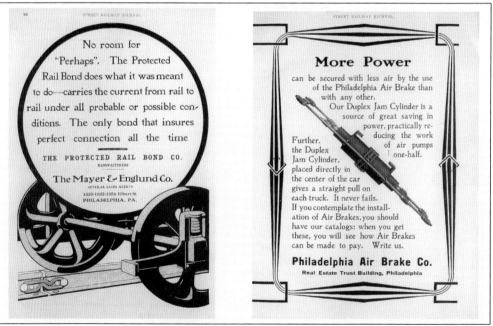

The Mayer and Englund Company (left) made electric bond parts for the St. Louis Car Company at its Philadelphia factory. The electric bond provided a continuous way for the electricity to flow from the source and return back to the ground. The Philadelphia Air Brake Company (right) invented the duplex jam cylinder, which stopped all four wheels evenly with less pressure. (Robert Skaler.)

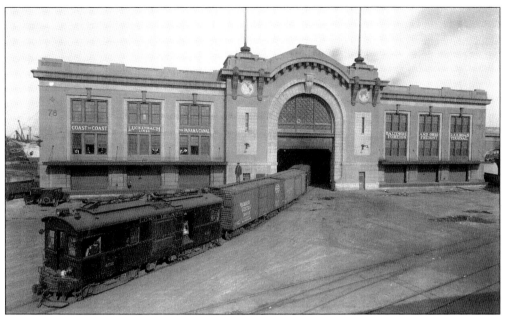

The J. G. Brill Company specialized in the manufacture of vehicles that ran on the rails. The company moved to more spacious acres in Southwest Philadelphia at Fifty-eighth Street and Woodland Avenue, producing railroad items beginning in the 1860s. This great photograph shows a Brill-built diesel locomotive engine pushing a train into Municipal Pier No. 78 on a test run before sending it to the Long Island Railroad in March 1926. (Bob Foley.)

Philadelphia's Budd Wheel Company, with its headquarters at one time on Hunting Park Avenue in the Nicetown section of Philadelphia, made parts for the transportation industry, including the famed silver "Almond Joys" for the Market Street El. The Company's logo of a wheel with wings refers to Mercury, the mythological god of speed and motion. (Joel Spivak.)

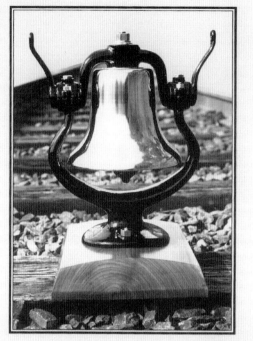

THE PENNSYLVANIA RAILROAD BELL™

OWN A PIECE OF AMERICAN RAILROADING HISTORY

The old Baldwin Locomotive Works in Eddystone held the blueprints for the future of the Giesler Engineering Company. This company brought old locomotive relics back to life by manufacturing bronze bells of various scale for use on trains and in dedication ceremonies. The bells are treasured in America and around the world. (Greg Giesler.)

The Schuylkill Arsenal, formally known as the U.S. Arsenal, provided a central workshop for all war material dated back to an act of Congress in the late 18th century. Situated along the east bank of the Schuylkill River, the arsenal complex shipped goods via the Schuylkill River and later by the new railroad. General Lee had planned to attack Philadelphia after Gettysburg due to its strong railroad connections to the South. (Joel Spivak.)

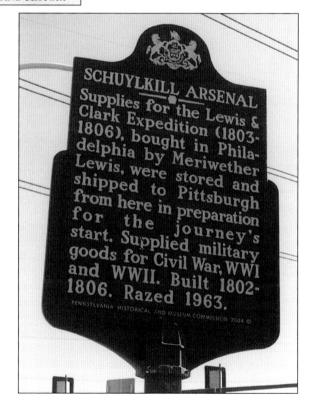

Four

STATIONS AND TERMINALS

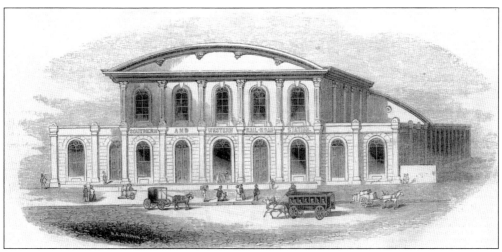

As people began to move to other areas outside the original city limits, they needed access to the railroad stations. The station pictured above is known in railroad circles as the "Broad and Washington Railroad Station," although its real name inscribed above the entrance, Southern and Western Railroad Station, perhaps defines its larger importance. Once a train left its handsome brownstone edifice, it followed the tracks over Gray's Ferry Railroad Bridge into the southwest districts of Philadelphia and made its way to Wilmington, Delaware, and points south and west of Baltimore, Maryland. (Free Library of Philadelphia.)

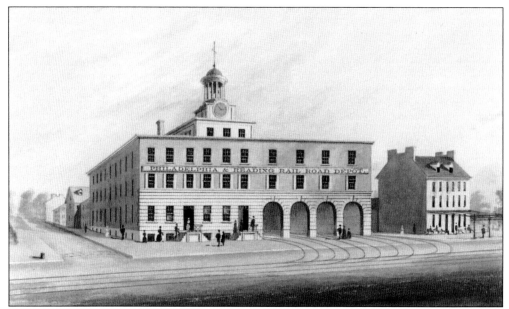

The Philadelphia and Reading Railroad (1833) chose prime available real estate to build their depot at Broad and Cherry Streets above Arch Street, which radiated out from the core of the original city borders, as seen in this 1840 rendering by artist David Kennedy. Philadelphia awaited the arrival of the steam locomotives and used horse-drawn trains. (John Johnstone.)

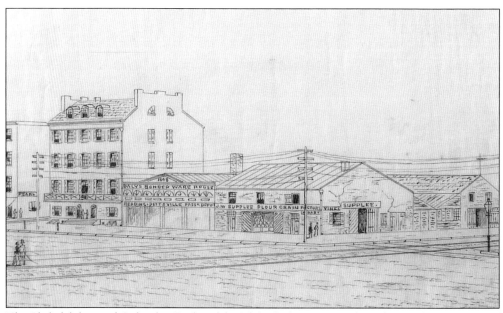

The Philadelphia and Columbia Railroad (1831) built their terminal on the northeast corner of Broad and Vine Streets in 1832, northwest of the city at the time. Seen in this drawing by B. R. Evens is the West Chester Railroad (1831), which had access along the Philadelphia and Columbia Railroad and built a hotel adjacent to the station. (Free Library of Philadelphia.)

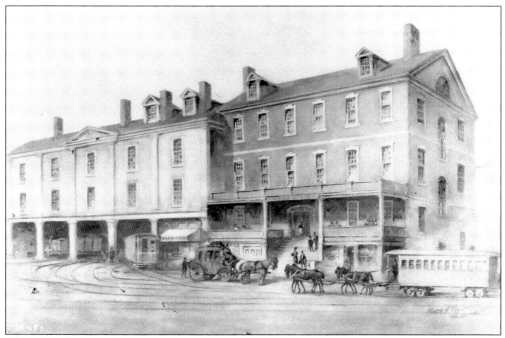

The Pennsylvania Railroad (1846) built its first railroad station on the southeast corner of Eleventh and Market Streets in Philadelphia. Trains were disconnected from their locomotives on the west side of the Schuylkill River, and teams of mules drew the cars and passengers into the city along Washington Avenue then up South Broad Street to Market Street. The Mansion Hotel allowed weary railroad workers a place to rest. (Free Library of Philadelphia.)

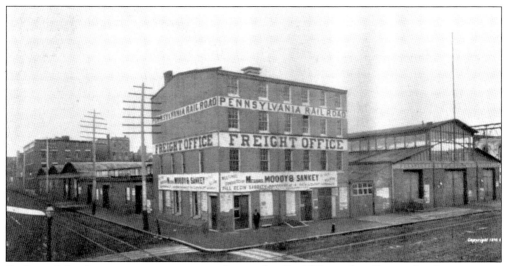

Dedicated freight stations came into use during the Civil War to handle supplies being sent to the troops. The Pennsylvania Railroad built their first freight facility on the southwest corner of Thirteenth and Market Streets. John Wanamaker, pioneer department store owner, moved his business and converted the depot into a retail store in 1876. (Frank Weer.)

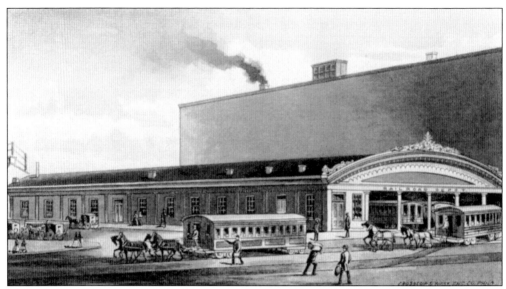

The opening of the permanent bridge over Market Street (1850) led to development west of Broad Street. The Philadelphia and Columbia Railroad abandoned the Belmont Plane in the same year and sent its trains through West Philadelphia over the newly acquired West Philadelphia Railroad (1835) to its new depot at Eighteenth and Market Streets, again leaving the locomotives in West Philadelphia. (Chuck Denlinger.)

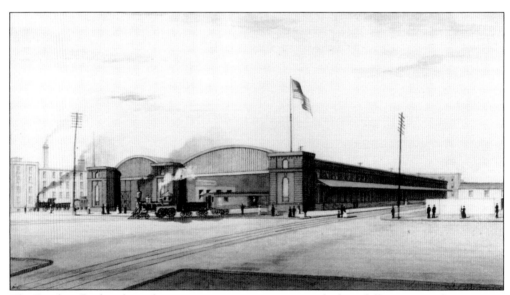

The Reading Railroad sought more spacious quarters to park their full-size steam locomotives by hopping over the Pennsylvania Railroad depot at Broad and Vine Streets to their new depot at Broad and Callowhill Streets in the early 1870s. After the Civil War, the city, only recently consolidated, started its growth to the north and west. Railroads and their track beds dictated this move beyond Broad and Spring Garden Streets. (John Johnstone.)

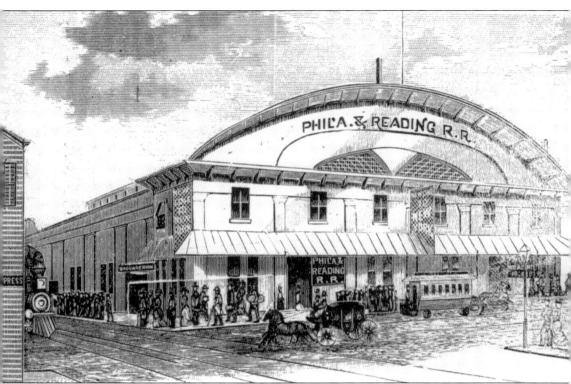

Railroads changed hands after the Civil War on a frequent basis. The Reading Railroad acquired the Philadelphia, Germantown, and Norristown Railroad in 1870. A modern terminal and station was built at Ninth and Green Streets above Spring Garden Street. The rounded roofline of the terminal developed because of advances in materials and engineering knowledge. (Free Library of Philadelphia.)

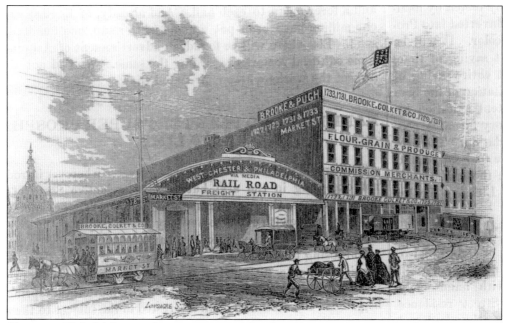

Change in Philadelphia was key to its successful railroad history. Centers of influence came and went with different eras. When the Philadelphia and Columbia Railroad moved its depot to Eighteenth and Market Streets, so did the West Chester Railroad, building a new freight depot at 1735 Market Street to accommodate the growing demand for product from the West Chester area. (Chuck Denlinger.)

Private freight depots developed in Philadelphia as industry grew in the 1870s. The capital was raised to start these original businesses, centrally located operations, such as the George Cookman freight depot on the northeast corner of Broad and Filbert Streets. Here the first open freight car for heavy loads can be seen. The Waverly ice depot is right next to Cookman's. The Arch Street Methodist Church is still there today. (Free Library of Philadelphia.)

The North Pennsylvania Railroad (1858) started as the North Branch Railroad (1846) and later existed as the Philadelphia, Easton, and Water Gap Railroad (1852). This rare lithograph shows the North Pennsylvania Railroad milk depot located at Third and Thompson Streets in the North Liberties District north of Girard Avenue. The fresh milk came from farms along the Delaware River and was distributed from Easton down to Philadelphia. (Free Library of Philadelphia.)

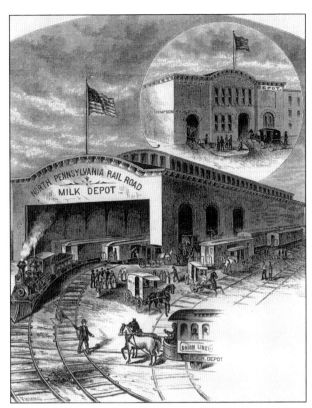

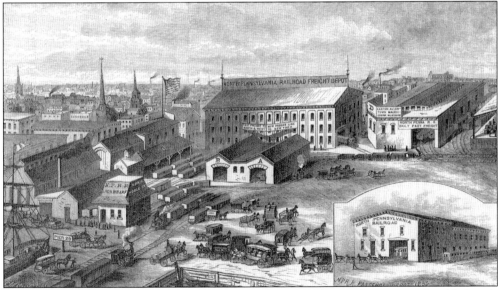

The prime location of Front and Willow Streets, just north of the city, became a railroad hub with the meeting of the North Liberties and Penn Township Railroad (1829) and the extension of the North Pennsylvania Railroad (1846–1858), which all met and shared the piers and wharves at the Delaware River. The Philadelphia and Trenton Railroad (1832) through Kensington fought to have their railroad terminate here, but the residents rioted, which led to the North Pennsylvania Railroad terminating there by default. (Free Library of Philadelphia.)

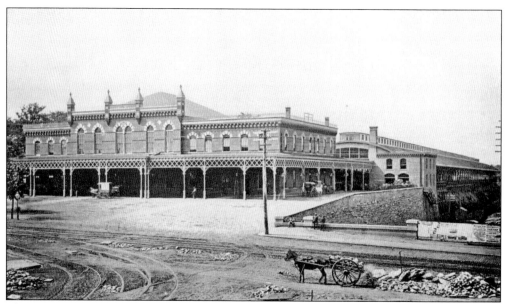

The first railroad station built at Market Street and Lancaster Avenue, just east of Thirty-second Street, was completed in 1875 in anticipation of the coming U.S. centennial celebration. The building, with its lattice front, could handle more passenger trains than any other station in the country. The facility served as the main Pennsylvania Railroad station until Broad Street Station opened in 1881. A fire destroyed this masterpiece in 1896. (Joel Spivak.)

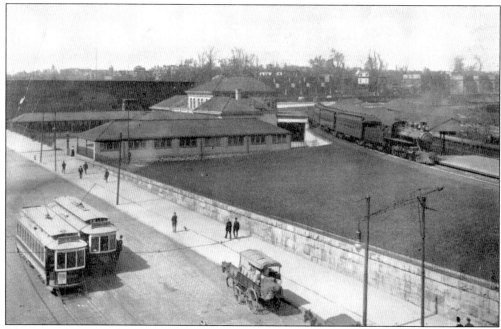

The Pennsylvania Railroad sought to build another railroad station at Thirty-second and Market Streets in the early 20th century to replace the one destroyed by fire. The new station became a central transportation hub with the advent of electric trolley cars to service West Philadelphia. (Joel Spivak.)

Broad Street Station, located on the west side of Market and Broad Streets, was erected in 1881 to bring steam locomotives into the city with a stub-end terminal. The Pennsylvania Railroad built this edifice in 1881, originally for its national headquarters, atop the two-story railroad station—the largest one in America during that era. The station was enlarged and embellished by famous architect Frank Furness in 1894 to compete with the Reading Railroad's new terminal only three city blocks away at Twelfth and Market Streets. (Joel Spivak.)

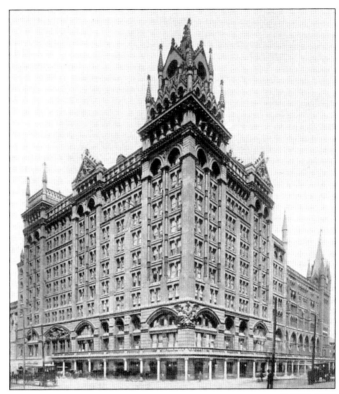

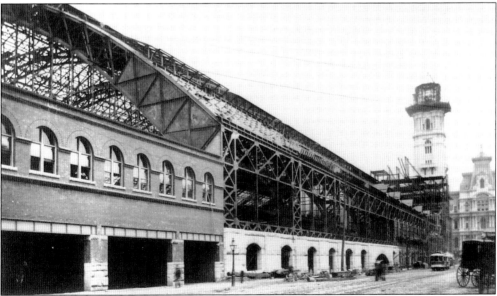

The extension of the Broad Street Station and its access to the railroad bridge over the Schuylkill River was carried two stories high over its well-known Chinese Wall Viaduct that straddled eight streets before crossing into West Philadelphia and redirecting trains in all directions. The train shed, when built, reached a world record of 306 feet. With the building of the Pennsylvania Railroad's Thirtieth Street super hub in the 1930s, the Broad Street Station declined and was razed in 1952 to make way for the Penn Center office buildings. (Joel Spivak.)

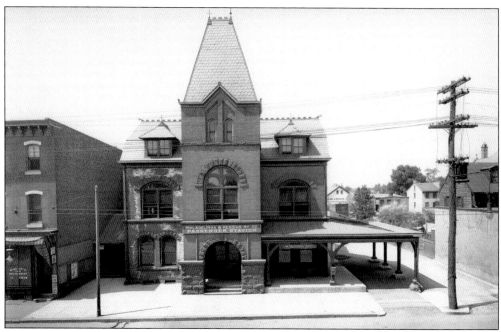

The Frankford depot and terminal, located at 4400 Frankford Avenue and Unity Street, served the Philadelphia and Frankford Railroad (1892). Frank Furness designed the station. The branch, with a connection to the main trunk line of the Reading Railroad system, connected to the downtown area and ran through portions of Northeast Philadelphia until the 1980s. (Frank Weer.)

The Philadelphia and Frankford Railroad built several stations along its route, including Arrott Street station located two blocks south of Castor Avenue. The small waiting room for patrons of the line was a homey environment with a potbelly stove for heat in the wintertime and a residence for the ticket agent. In the middle of this 1890s photograph, one can view a tin water cooler atop a wooden stand. (Frank Weer.)

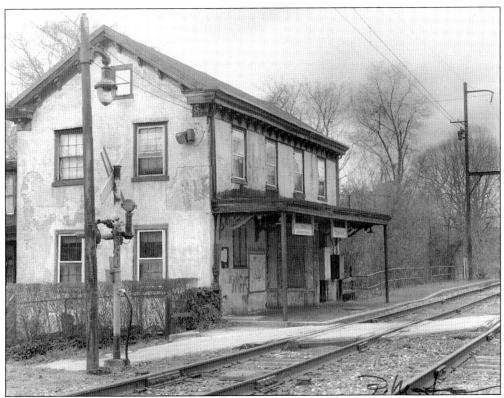

The oldest-surviving railroad station in America is the Shawmont station, which was built in 1834 along the Philadelphia to Norristown corridor with a southerly connection in Manayunk. The towpath of the Manayunk Canal ends nearby, which was part of the Schuylkill River Navigation and Canal Company that dates back to 1809. (Frank Weer.)

Name changing is part of railroad history in the Philadelphia region. Hidden in the annals of history, a "Circular" published by the Philadelphia and Reading Railroad dated August 4, 1873, communicated the name change of the Green Tree station to Shawmont. Agents, officers, express agents, and messengers all received notice of the change. (John Johnstone.)

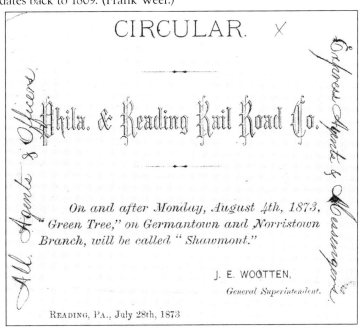

CIRCULAR.

Phila. & Reading Rail Road Co.

On and after Monday, August 4th, 1873, "Green Tree," on Germantown and Norristown Branch, will be called " Shawmont."

J. E. WOOTTEN,
General Superintendent.

READING, PA., July 28th, 1873.

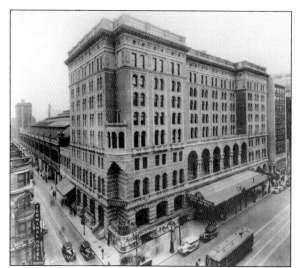

The Philadelphia and Reading Railroad decided to build an extension access route into downtown Philadelphia through its western line (City Branch) and its northern line (former Philadelphia and Germantown Railroad) via a subway and elevated viaduct that lead to Twelfth and Market Streets. This central location was where the Reading Terminal was erected and the famed fresh farmers' market in 1893 took place. (Philadelphia City Archives.)

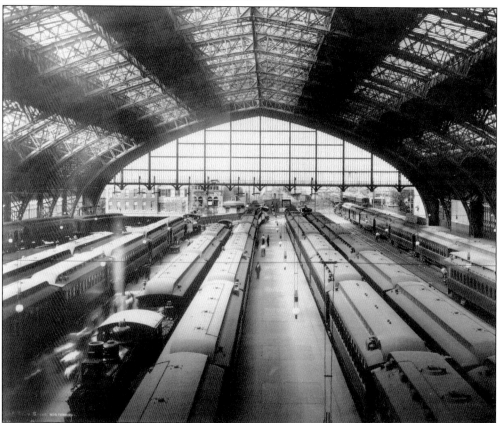

The Reading Terminal provided many Reading Railroad passengers access to the downtown district on the east side of Market Street, where well-known department stores such as Lit Brothers, Wanamaker's, Strawbridge and Clothier, and Gimbel Brothers were located. A hot meal awaited train goers at the new Automat restaurant, featuring self-service dining. The dispensing system of the Horn and Hardart chain on the ground floor at Market Street was a popular stop for travelers. (Frank Weer.)

Philadelphia expanded its residential living quarters in the early 20th century, and railroads were forced to vacate their shared private right-of-ways if they wanted to continue doing business in the city of Philadelphia. The former South and Western Railroad, now under the control of the Baltimore and Ohio Railroad, moved into their new passenger station designed by Frank Furness in 1888. Meanwhile, Prime Street was changed to Washington Avenue, and the bustle of the city migrated to create South Philadelphia. (Joel Spivak.)

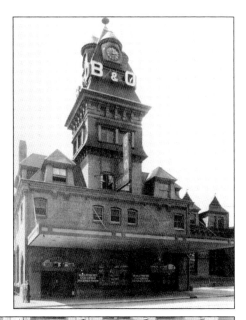

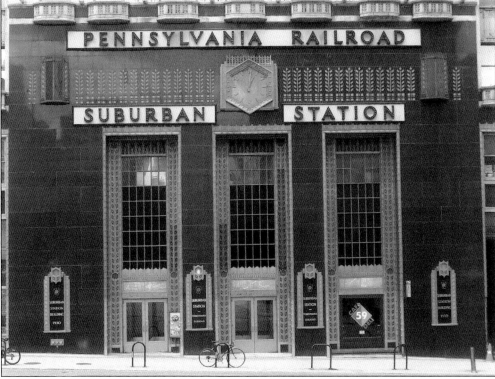

Philadelphia (Broad Street) Suburban Station, located at Sixteenth Street and John F. Kennedy Boulevard opened in 1930 as a stub-end facility of the Pennsylvania Railroad to allow suburban office workers a straight path into Center City Philadelphia. The commuter station took on more importance when the nearby Broad Street Station closed in early 1950s. It is now a part of the through regional train system since the completion of the Commuter Tunnel in 1984, linking the two former major railroad lines that were stub-end railroads. (Joel Spivak.)

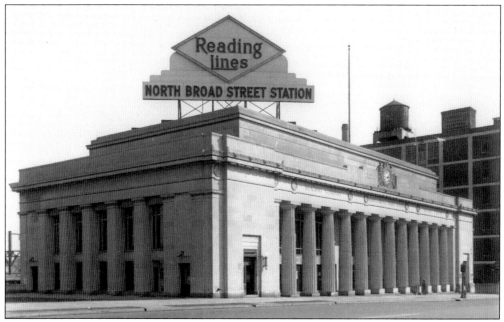

North Broad Street Station along the Reading Railroad Line at 2600 North Broad Street is below Lehigh Avenue and was designed by architect Horace Trumbauer. It opened in 1928 north of Temple University. Investment in the properties owned by the Reading Railroad in Philadelphia came during the boom years of the 1920s, as the Baltimore and Ohio Railroad had their executives on the Reading's board and anticipated a takeover of the Reading so that Baltimore and Ohio could have a through route to New York. The plan to make this station the Baltimore and Ohio Railroad's central address in Philadelphia came to a halt with the Stock Market Crash of 1929. (Frank Weer.)

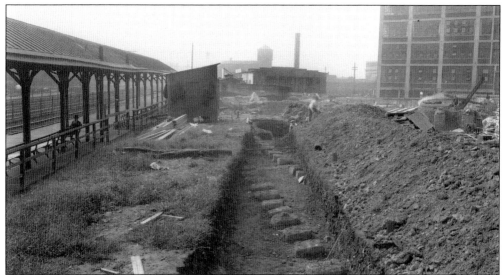

Industrial Archeologists in Philadelphia had a field day when Philadelphia's railroad history was excavated to make the foundation for the new North Broad Street Station at 2600 North Broad Street in the late 1920s. The former railroad bed, complete with stones used to anchor the rails of the Philadelphia, Germantown, and Norristown Railroad (1831), was uncovered from 100 years ago at this site. (Frank Weer.)

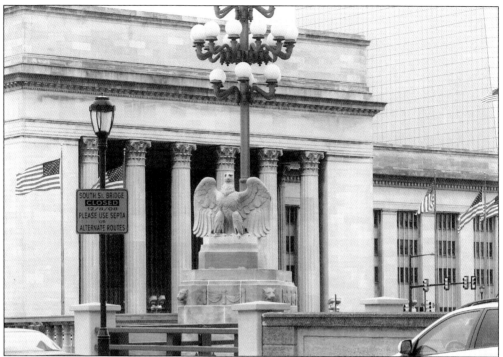

The main railroad station in Philadelphia, originally known as Pennsylvania Station at Thirtieth Street, came on line in 1933. The rise of this area as a national railroad hub grew in importance as the electrification of the railroads from Washington to New York became known as the Northeast Corridor. The eagle in this photograph is a one of four rescued from Penn Station in New York City when the building was razed in the 1960s, giving way to the preservation movement across America. (Joel Spivak and Allen Meyers.)

Designed by architect Theophilus Chandler, the North Philadelphia Station along the Pennsylvania Railroad's main line to New York City served the general community of North Philadelphia in 1901. The station, located at 2900 North Broad Street and Glenwood Avenue, served as a gathering point for patrons of the Philadelphia Athletics Major League Baseball team with a continuous line of fans going to Shibe Park Stadium (1909), seven blocks away at Twenty-second Street and Lehigh Avenue. (Joel Spivak.)

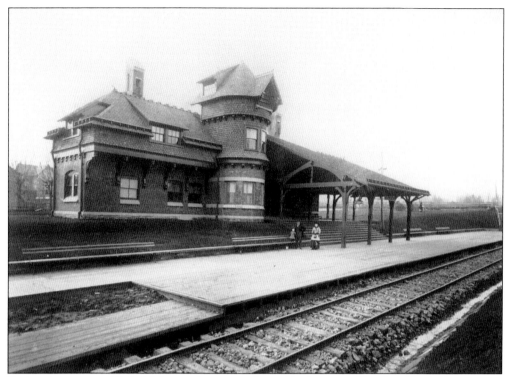

Railroad stations in Philadelphia took on a residential look, especially when Frank Furness was the architect for Gravers (Lane) station along the Philadelphia, Germantown, and Chestnut Hill Railroad (1883). Complete with a turret to watch the trains come in and the protection of a porch-type overhang for inclement weather, the Graver's Lane structure received no less attention from the architect than if it were his own residence. The Reading Railroad acquired this railroad and named it the Chestnut Hill East Line to differentiate it from the Pennsylvania Railroad's Chestnut Hill West Line (1884). (Frank Weer.)

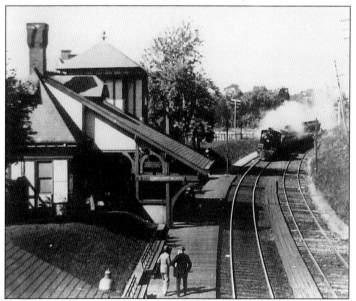

The Reading Railroad saw the completion of the Pennsylvania Railroad in the northwest section of Philadelphia and sought to challenge them by building bigger railroad stations. The Reading Railroad hired Frank Furness, the primary architect for the Pennsylvania Railroad, to accomplish that feat. Picture-card perfect is the only way to describe the Mount Airy station, which is three stops from its terminus in Chestnut Hill. (Frank Weer.)

As the Philadelphia and Columbia Railroad entered the suburbs of Philadelphia only 11 miles away, the Whitehall station was built along the original alignment of the Main Line. The station still stands today on Railroad Avenue at Township Road and is the thrift shop of the Bryn Mawr Hospital. (Chuck Denlinger.)

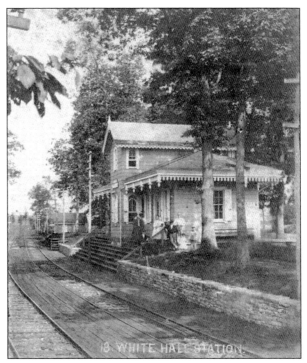

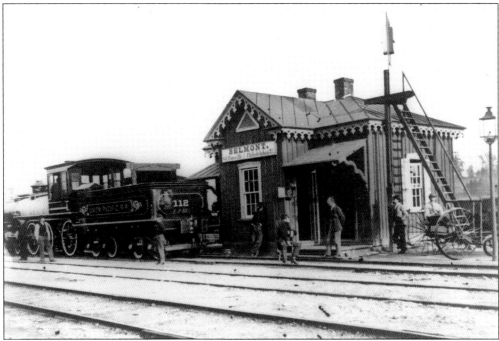

Here is a rare photograph of the Belmont station, which was located along the Philadelphia and Columbia Railroad. It was also the last stop before going up the Belmont Plane on its westward trek to Columbia beginning in the early 1830s. North-south railroad lines of the Reading Railroad (1833) and Junction Railroad (1860) made the Belmont station the first railroad hub west of the Schuylkill River after crossing the Columbia Railroad Bridge in Philadelphia. (Frank Weer.)

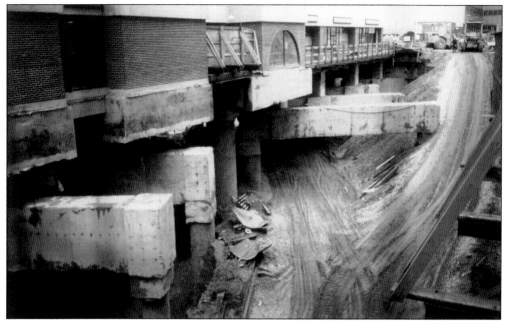

Talk of connecting the Pennsylvania Railroad with the Reading Railroad in Philadelphia increased just prior to World War I, but the question was how to do it. The railroads were elevated two stories above ground at both of their respective stub-end terminals. A graduate of the University of Pennsylvania and a junior planner on the Philadelphia Planning Commission, R. Damon Child proposed the Center City Commuter Tunnel after the bicentennial (1976) to finally connect the two lines and make a through train system, which was completed in 1985. (Larry De Young.)

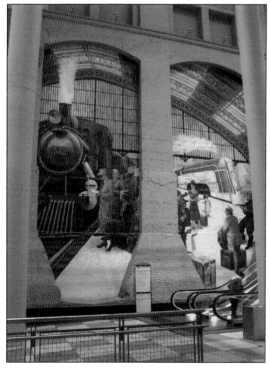

Entrance to the Center City Commuter Tunnel is accessible through the Market East Station concourse that runs for blocks. Artwork in the form of wall murals is a favorite tradition in Philadelphia. This mural located in the East Market Station, which connects to the Gallery Mall, tells a story of a bygone era when steam locomotives stopped at the Reading Terminal more than 50 years ago. (Joel Spivak.)

Five

JUNCTIONS

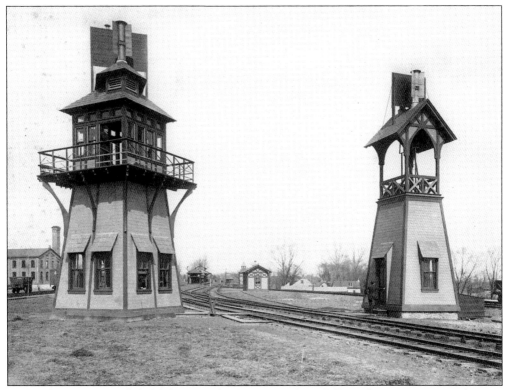

Railroad junctions in Philadelphia served as locations where different lines came to together in a limited amount of space. The need to keep all the trains moving meant that some had the right of way, while others had to stop and wait, forcing traffic signals to evolve greatly over time. The unique architecture of these signal towers (1881) at Wayne Junction, designed by architect Frank Furness, allowed for a 360-degree line of sight for all incoming and outgoing traffic. During the Civil War, the Reading Railroad continued to move anthracite coal, which produced less smoke and burned better than any other fuel of its kind. Pres. Abraham Lincoln nationalized and took over only the Reading Railroad due to the fact that the coal was the lifeline of the Union Navy. (Ted Xaras.)

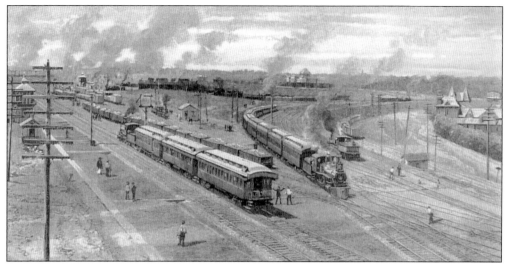

The section of the city up along the west banks of the Schuylkill River was known as Mantua. This area received great attention in 1850 when the Pennsylvania Railroad leased the Philadelphia and Columbia Railroad and acquired the West Philadelphia Railroad as an alternative to the Belmont Plane. The Pennsylvania Railroad built the stretch of railroad through Mantua to access the Market Street Permanent Bridge (1850). (Free Library of Philadelphia.)

The Mantua Junction came into importance when other railroads were built in this area and Philadelphia opened the nation's first zoological garden at this intersection in 1859. The Junction Railroad (1860) came down from the Belmont station along one side of this junction, which allowed trains safe passage without stopping. The Connecting Railroad (1863) traveled along a new bridge over the Schuylkill River and used the northwest section of the junction. Today the signal tower is known as Zoo Junction. (Allen Meyers.)

The track map for Germantown Junction is a valuable piece of railroad real estate that is located in North Philadelphia. This is where the Connecting Railroad (1863), with its cross-city route to Frankford, is met by the original Philadelphia, Germantown, and Norristown Railroad, which was acquired by the Reading Railroad in 1870. The Connecting Railroad was acquired by the Pennsylvania Railroad. (Frank Weer.)

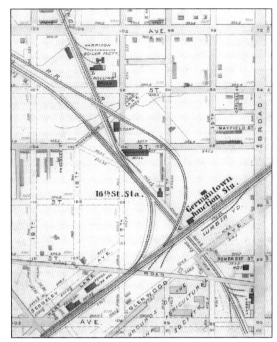

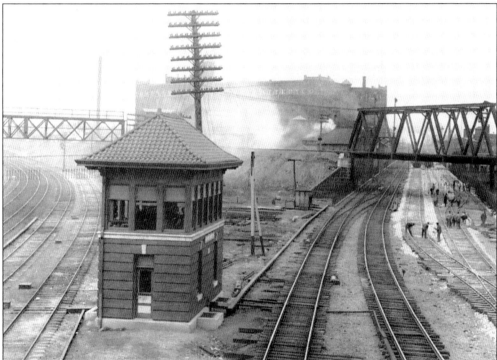

While it directed trains to their final destinations, the Sixteenth Street Junction went through a number of name changes and buildings during the latter half of the 19th century. The Iron Age allowed for the massive crossover of several railroads with truss bridges. The Sixteenth Street tower sits strategically perched between this very important junction to direct train traffic safely around this integrated track setup. (Hagley Museum and Library.)

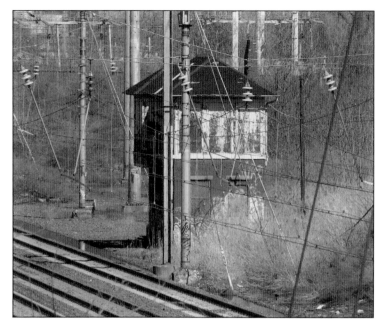

The Brill Tower in Southwest Philadelphia, near Fifty-eighth Street and Grays Avenue, served two railroads. The signal tower, now abandoned, also directed traffic to the private siding of the J. G. Brill Company, which was located on the other side of the tracks. The J. G. Brill Company made trains and trolley cars for Philadelphia and cities around the world. (Allen Meyers and Joel Spivak.)

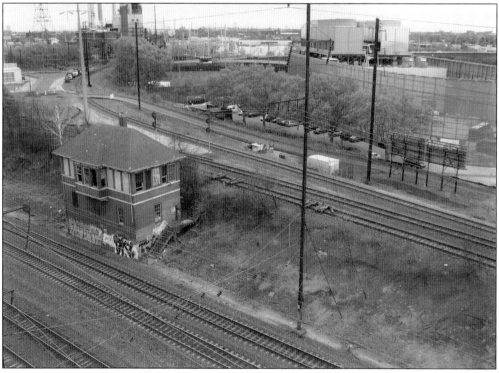

Once a train passed the Brill Tower and its controlled switching to the High Line (an elevated railroad built in 1903), it would come to the Arsenal Tower and its interlocking control to receive directions on how to proceed. The two railroad systems intersected after coming off the Arsenal Railroad Bridge, which brought train traffic into South Philadelphia and the Delaware River piers. Only freight trains were allowed to move above the busy Thirtieth and Market Street railroad hub. (Allen Meyers and Joel Spivak.)

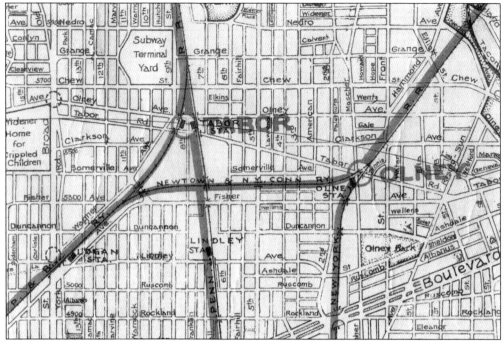

Tabor Junction sits along the merge point of the North Pennsylvania Railroad and Tabor Branch Railroad (1876), connecting it to the highly industrial Nicetown section of Philadelphia. Philadelphia's first Jewish hospital, founded in 1864, relocated from West Philadelphia to the end of Tabor Road in 1873 in advance of this important Philadelphia railroad event. This area is unique in that it had two stations named Tabor before its merge with the Philadelphia and Newtown Railroad (1860) at Newtown Junction. (Frank Weer.)

Industrial archeology was employed when uncovering the remains of the once important Fairhill Junction in the North Philadelphia–Kensington border at Third and Clearfield Streets. The top bridge took the North Pennsylvania Railroad over the Richmond Branch Railroad. Both railroads eventually were under the control of the Philadelphia and Reading Railroad when the Reading acquired the North Pennsylvania Railroad in 1879. (Allen Meyers and Joel Spivak.)

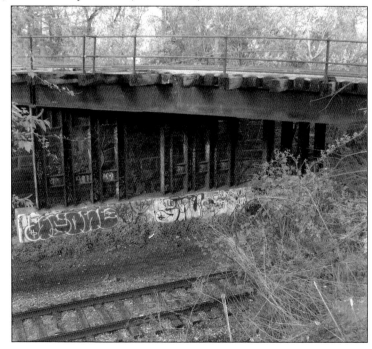

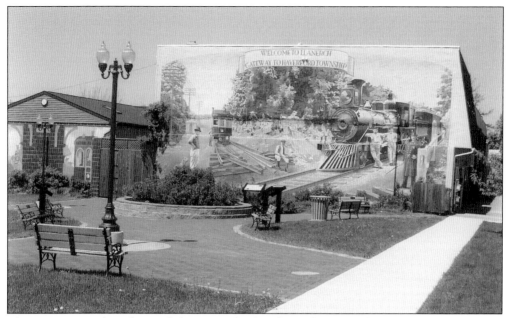

The competition for riders and the issue of right-of-ways between the Pennsylvania Railroad and the West Chester (Steam Chartered Railroad) trolley line (1896) is depicted in this mural painted by Jarad Bader at West Chester Pike and Lansdowne Avenue in Llanerch Crossing and Park. (Haverford Township Historical Society and Llanerch Civic Association.)

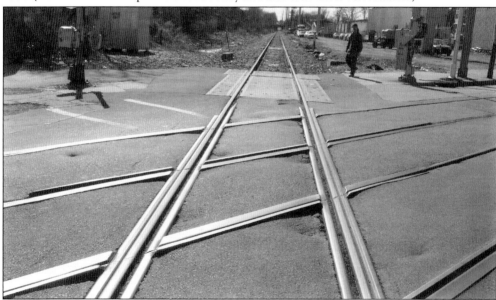

The "frog wars" (when a private railroad company attempts a crossover switch to straddle the tracks of another) were fought, lost, won, or tied based at the local municipality level throughout Philadelphia. Since there was wide-open space where each railroad could run, the intersection of railroads in the 1800s was not an issue. The urbanization of these communities now found two railroads crossing each other in one locality. The Darby Improvement Company built a new alignment here at Fifth Street near Main Street in Darby. The solution is in favor of the only remaining Class I railroad crossing in America. (Allen Meyers and Joel Spivak.)

Six

BRIDGES AND TUNNELS

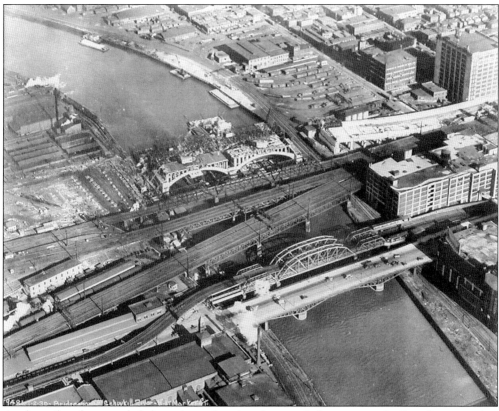

As the railroads expanded throughout the city, they needed to traverse bodies of water, other railroads, or streets filled with electric trolley lines. Nothing got in the way of the railroads, and sometimes tunnels or bridges were constructed to bypass various obstacles. Bridges were made in all sizes. Initially the bridges were constructed of wood, which progressed to wrought iron, steel girders with piers, and reinforced concrete. The photograph above shows the many bridges that exist today around Market Street to service the railways: Suburban Station, the old Pennsylvania Railroad tracks to the Chinese Wall, the truss bridge that carried the Market Street Subway, the streetcar subway, and the Market Street Bridge itself. (Joel Spivak.)

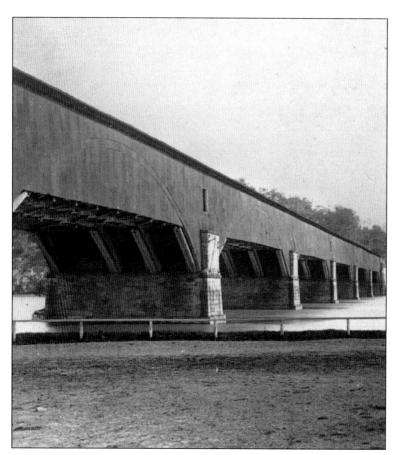

The first Columbia Railroad Bridge across the Schuylkill River (1834), near Peter's Island, carried the Philadelphia and Columbia Railroad from the eastern banks of the Schuylkill River to its western banks, thus creating a connection to the Belmont Plane, which was used to haul freight and railroad cars to the top. Prior to the completion of the bridge, passengers and freight were ferried across the river. (Fairmount Park Resource Archives.)

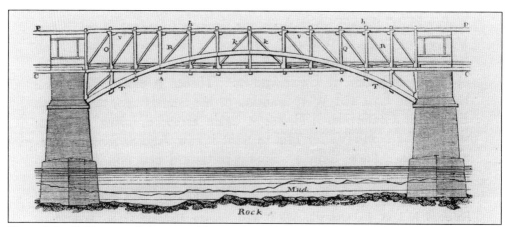

Here is John C. Trautwine's drawing of the wood truss bridge of the Columbia Railroad Bridge. This bridge remained in use until an iron structure was built 52 years later in 1886 by the Phoenix Iron Company in Phoenixville, Pennsylvania. (Delaware County Historical Society, Pennsylvania.)

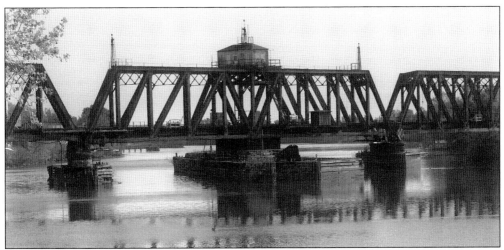

The active swing bridge at Gray's Ferry is located below the current street traffic of Gray's Ferry Avenue Bridge. The Baltimore and Ohio Railroad constructed this bridge in 1910 over the Schuylkill River with its new alignment (1883) to the southwest at Fifty-eighth Street and Gray's Avenue. On the east side of the Schuylkill River, the current CSX Railroad (1999) runs through the East Side freight yard along the former Schuylkill River East Side Railroad (1883). (Joel Spivak.)

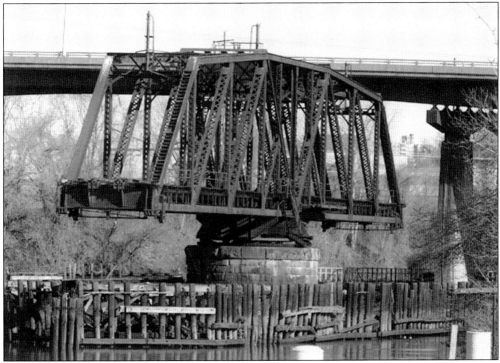

The inactive swing bridge right below Gray's Ferry Avenue Bridge is stuck in the open position. The Pennsylvania Railroad and the American Bridge Company built the bridge in 1902. The Gray's Ferry crossing, which dates back to 1836, over the Schuylkill River was used by the Philadelphia, Wilmington, and Baltimore Railroad. Barges and ships carried timber, refined oil products, stone, and clay bricks in both directions. More loads meant tall ships went up to Spruce Street, creating the need for a swing bridge. (Allen Meyers and Joel Spivak.)

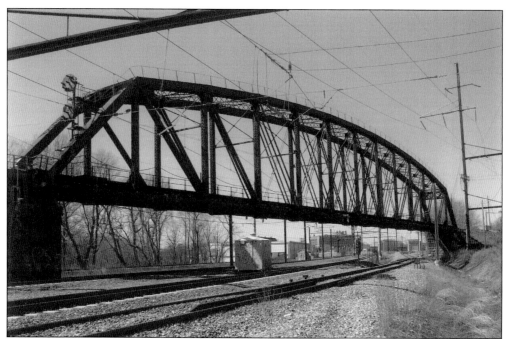

The dynamic Fifty-second Street intersection has two railroad lines, a freight line, and a huge ridership opportunity. The separation of the passenger line from the freight line gave rise to more thought and planning. A "fly over," the bridge for the Pennsylvania Railroad going to Bala Cynwyd is 387 feet. The bridge construction is a Parker through truss. (Allen Meyers and Joel Spivak.)

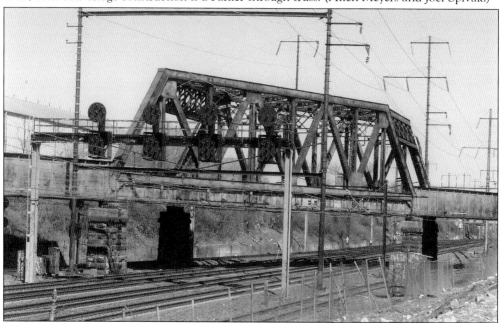

Here is another "fly over" railroad Pratt truss bridge (patented 1844) that takes freight over the main line of the Pennsylvania Railroad. Meanwhile, the southwest bridge goes under Sixtieth Street and along the new Philadelphia, Wilmington, and Baltimore Alignment to Darby at Fifth and Main Streets. (Allen Meyers and Joel Spivak.)

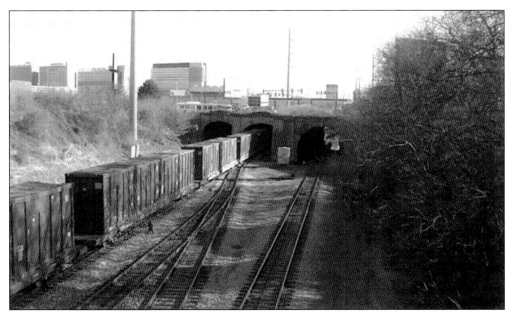

All three tunnels under Gray's Ferry Avenue were man made and service two railroads that travel southwest of Philadelphia. The road that runs on the top of these man-made tunnels leads a short distance to the University Avenue drawbridge over the Schuylkill River, which was raised and lowered to let tall ships sail upriver as far as Spruce Street. (Allen Meyers and Joel Spivak.)

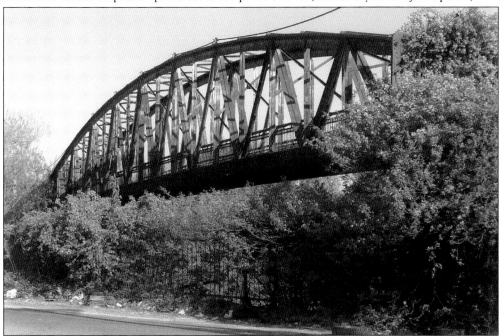

The neighborhood adjacent to the Schuylkill River and Gray's Ferry, which is now cut off by the East Side freight yard and the Schuylkill Expressway, is known as the "Forgotten Bottom." The steel truss bridge seen in this photograph is a footbridge that was once used to access the area where the public elementary and junior high schools are located, near Thirtieth and Tasker Streets. (Allen Meyers and Joel Spivak.)

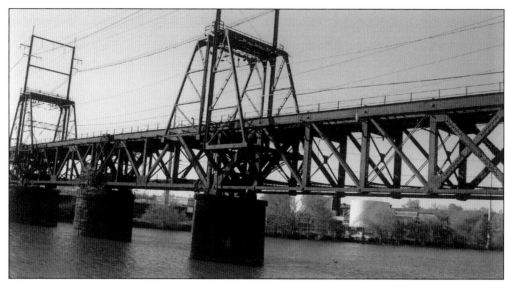

The Pennsylvania Railroad built the Arsenal Railroad Bridge, located about a mile up the Schuylkill River from the University Avenue Bridge. In 1861, civil engineer Jacob Hays Linville designed it. The bridge consists of two fixed 192-foot spans flanking a 192-foot center swing span. Linville held several patents for his truss bridge building. (Joel Spivak.)

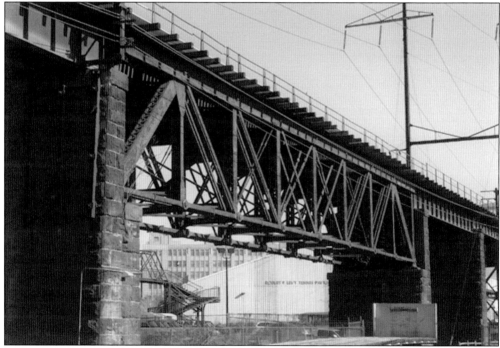

The High Line (a dedicated freight line), built by the Pennsylvania Railroad in 1903, developed as a response by the Philadelphia and Reading Railroad to separate passenger lines from freight lines for the safety and speed of all trains through the Thirtieth Street railroad hub. Upon inspection of the High Line south of Market there is large truss bridge across some vacant ground today. At one time, a spur ran under this span with a connection at Thirty-second and Market Streets on the east side. (Allen Meyers and Joel Spivak.)

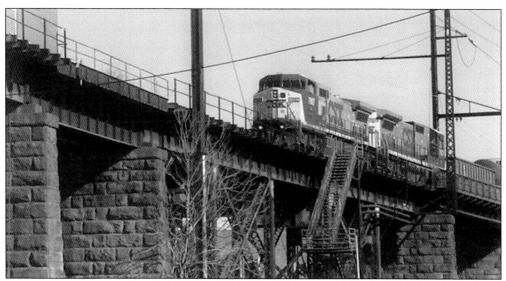

During periods of high-volume freight traffic, the CSX Freight Railroad Company, now the current owner of the former Baltimore and Ohio Railroad, awaits clearance to move trains with many boxcars. The High Line constructed in the early 1900s allowed freight-only trains a dedicated route over the busy Thirtieth and Market Street passenger railroad hub. The CSX train is heading south on the High Line to cross the Arsenal Railroad Bridge for a trip to the Delaware River piers. (Allen Meyers and Joel Spivak.)

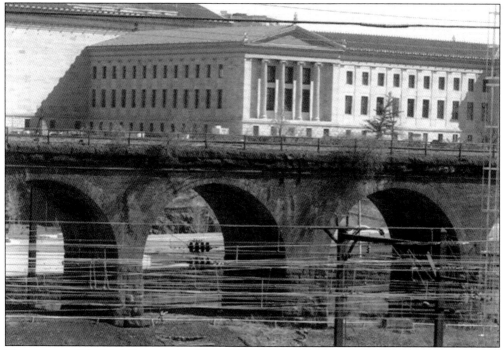

The portion of the High Line north of Spring Garden Street was constructed by Sparks and Evans as a series of pin-connected brick arches with riveted deck trusses and half-through girders. There are 30 brick arches on the stone piers on the way to Thirty-fourth Street, near the Philadelphia Zoo. (Allen Meyers and Joel Spivak.)

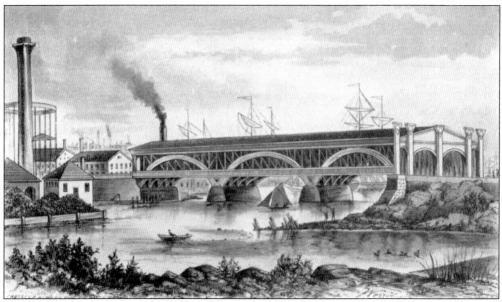

The Market Street Bridge of 1850 over the Schuylkill River had several predecessors dating back to 1801. The Market Street Permanent Bridge was built as the first covered bridge in America for commercial and public use. The significance of this vital connection is bore out by the building of the West Philadelphia Railroad, south of the bridge. A railroad was set on the bridge, but only horses could pull the cars to the new railroad depot at Eighteenth and Market Streets. (Joel Spivak.)

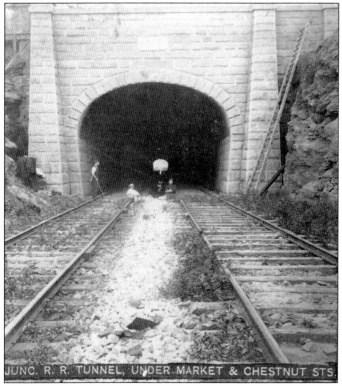

The often-talked-about tunnel under Market and Chestnut Streets was built in 1886 to carry the Junction Railroad (1860) from the Belmont station and the Main Line, with trackage rights now owned by the Pennsylvania Railroad, to intersect with the Arsenal Railroad Bridge. The new Philadelphia Subdivision Railroad (1888) capitalized on these developments from the zoo down to the Arsenal Railroad Bridge. (Chuck Denlinger.)

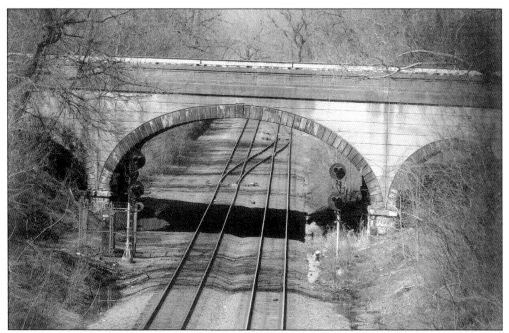

The elusive Connecting Railroad Bridge over the Philadelphia and Reading Railroad is a brick-arch overpass. This bridge is the earliest project of grade separation and was constructed between 1912 and 1915. It is located on the west side of Thirty-third Street, north of Girard Avenue. (Allen Meyers.)

All tunnels in Philadelphia are cut-and-fill projects with reinforced roofs placed on top. The creation of the Benjamin Franklin Parkway project, planned in the first decade of the 20th century, was put on hold until the end of World War I. The Baltimore and Ohio Railroad built a tunnel under Eakins Oval in front of the planned art museum, connecting with tracks at Park Junction, near Thirty-first Street and Girard Avenue. (Allen Meyers and Joel Spivak.)

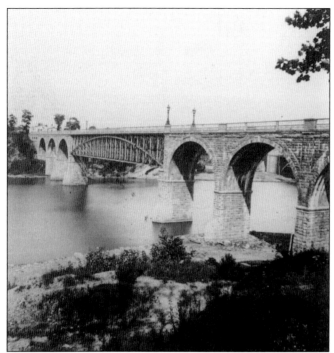

The Connecting Railroad (1863) Bridge over the Schuylkill River, just north of Girard Avenue, was built between 1866 and 1867. It was originally constructed with stone arches and a long truss in the middle. This bridge provided a connection from West Philadelphia to New York City for the Pennsylvania Railroad. The connection was made, and Mantua Junction became known as Zoo Junction. The northwest part of the junction, nicknamed the Pittsburgh Subway, ceased in the 1930s. The Broadway Limited had to stop at North Philadelphia Station and Thirtieth Street Station. (Fairmount Park Resource Archives.)

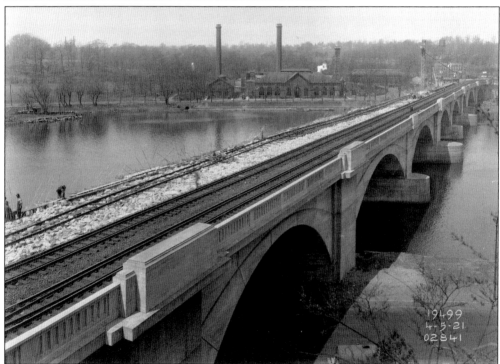

The construction of the third Columbia Railroad Bridge by chief engineer Samuel Tobias Wagner took shape in 1921. The importance of the new bridge meant that heavier loads could be shipped. The Belmont station became very busy with rail traffic heading along the west banks of the Schuylkill River, traveling south to Philadelphia and north to West Falls. (Hagley Museum and Library.)

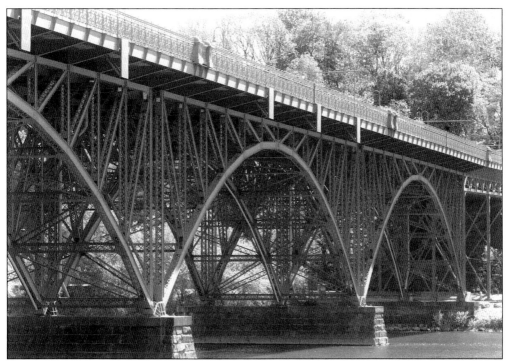

The Fairmount Park Transportation Company (1896) chose to build a trolley line due to the available technology in the form of electricity. To run the Fairmount Park Transportation Company's trolleys, the Phoenix Bridge Company built the Strawberry Mansion Bridge between 1896 and 1897. The trolley lines from the Strawberry Mansion section serviced the Woodside Park Amusement Center (Joel Spivak.)

The West Falls Bridge, built in 1853, helped to foster more east-west traffic, while increasing traffic north and south along the Schuylkill River. (Frank Weer.)

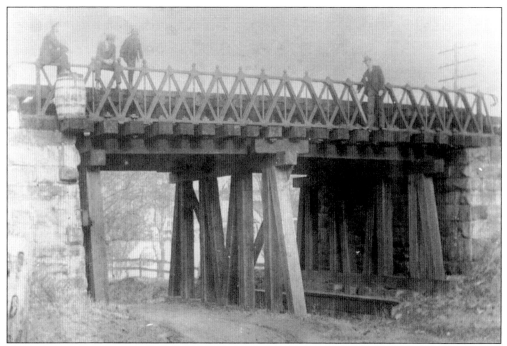

The first iron truss bridge built in America sat along the Reading Railroad, a short distance away from the Flat Rock Tunnel (1835). The bridge went up in West Manayunk on Mary's Water Ford Road in 1845. (Frank Weer.)

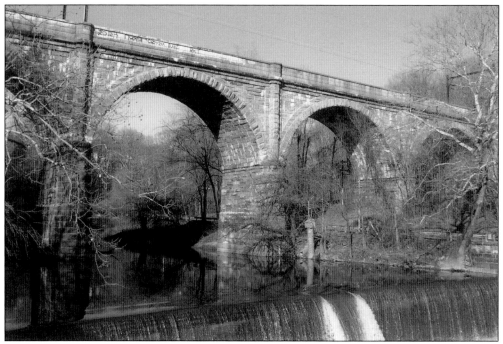

The Wissahickon Creek Viaduct, built in 1881, carries the Philadelphia Railroad's Manayunk/Norristown Line farther north. The beautiful setting is always nice to look at when driving by the area. Nolan and Brothers built the new bridge. (Allen Meyers and Joel Spivak.)

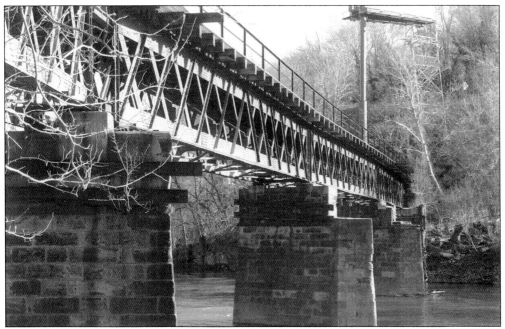

In Manayunk, the Mule Bridge (1889), also known as "Blackie Bridge," was built as a branch off the Reading, Lancaster, Lebanon, and Pine Grove Railroad (1846) to service industry on the Manayunk Canal. The wrought-iron, lattice-deck girder also incorporates the half-though plate girder. This bridge is one of the oldest surviving metal bridges in America. (Allen Meyers and Joel Spivak.)

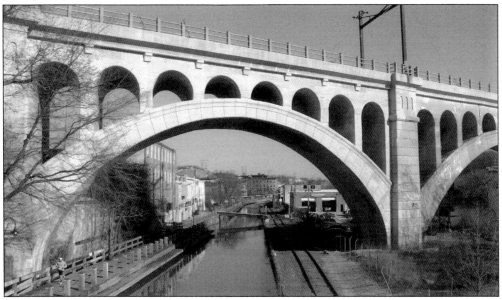

The Pennsylvania Railroad built its Schuylkill Valley Line (1884) from Fifty-second Street and Lancaster Avenue to Bala Cynwyd and then over a double-track, wrought-iron truss bridge over the Schuylkill River. The bridge was replaced in 1917 with a concrete exterior and an iron interior, connecting to the upper reaches of Manayunk. Some people call it the "Spanish Arch Bridge." (Allen Meyers and Joel Spivak.)

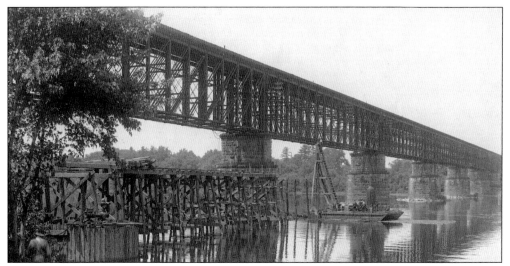

The Trenton Cut-Off Railroad (1891) provided a detour for freight trains to circumvent Philadelphia and end in Morrisville. Within 13 years, the grade to and from was lowered. The long bridge over the Trenton Cut-Off Railroad was raised in an effort to limit wear on the tracks. Today the Trenton Cut-Off Railroad runs parallel to the Pennsylvania Turnpike, some 30 miles from King of Prussia, to Morrisville. (Frank Weer.)

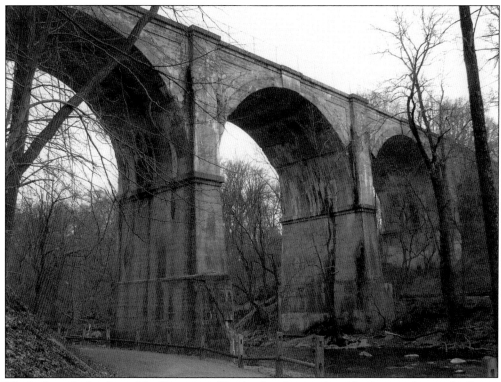

The high-vaulted arches of the Krewstown Road right-of-way railroad bridge travels over the Penny Pack Creek in Northeast Philadelphia and is still in use, recently celebrating its 100th anniversary. The freight line that runs from Cheltenham Junction, off Martins Mill Road, rumbles over this bridge several times a day. (Allen Meyers and Joel Spivak.)

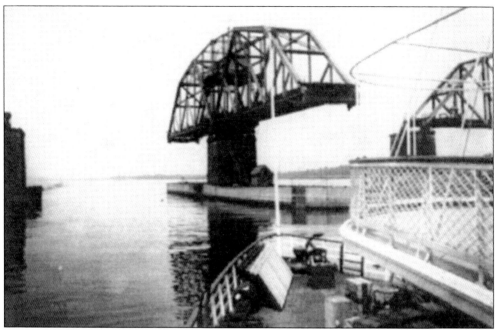

The Delaware River Railroad and Bridge Company (1896) built the Delair Railroad Bridge, which connected the Pennsylvania Railroad Seashore Line to Thirtieth Street Station via a long northern-tier loop though North and West Philadelphia. Built originally as a swing bridge for large oceangoing vessels, due to a ship hitting the bridge, it was converted into a lift bridge. The Delair Railroad Bridge is the longest railroad bridge in the Philadelphia region, with a length of 4,396 long. (Bridesburg Historical Society.)

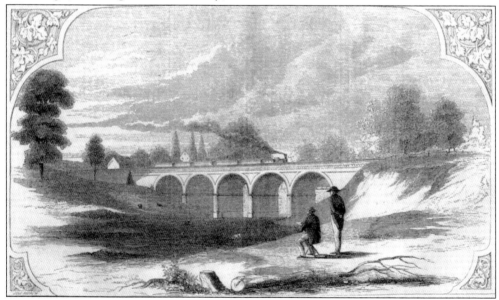

This very rare Lithograph depicts the Aramingo Viaduct over Gunner's Run, a small but strong flowing creek. The five-arch viaduct carried the North Pennsylvania Railroad (1852) over this ravine in 1856, when the railroad was extended to the Front and Willow Streets terminal and railroad hub in the Northern Liberties District. (Chuck Denlinger.)

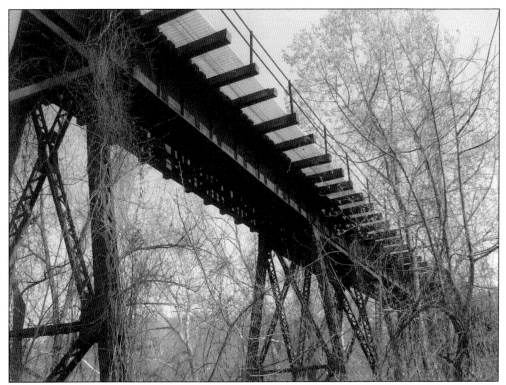

The Pennsylvania Railroad–Pickering Creek Railroad (1869) Trestle is outside of Phoenixville. Situated south of Buckwater Road in Chester County, this trestle spans more than 1,000 feet over Route 29 and scrub brush on its way to a quarry to access the rock and limestone for use in making pig iron into steel. This branch railroad is off the Schuylkill Valley branch line and is owned today by the Norfolk Southern Railroad. (Allen Meyers and Joel Spivak.)

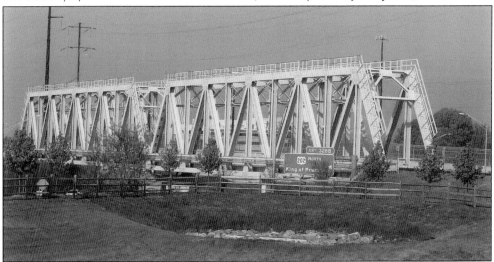

In 2002, the Schuylkill Expressway was widened at U.S. Route 202. An old black girder railroad bridge that spanned the highway for almost 60 years was removed, and the new double truss bridge spanning the wider highway was a welcome relief for many commuters. This bridge carries the still-active Trenton Cut-Off Railroad (1891) on its journey to Morrisville. (Joel Spivak.)

Seven

WORKING ON THE RAILROAD

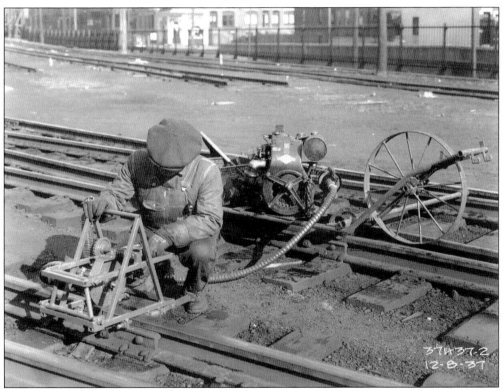

Railroad workers were a hearty bunch of men and women since its inception in the 1830s. Dedicated personnel stuck with the railroad upon leaving high school and remained on the job for the next 30, 40, and even 50 years before retiring. Getting a railroad job meant job security, which was acquired by hard work in addition to the efforts made by railroad union bosses who negotiated benefits for their members. The man in the above photograph isolated a bad piece of track and cut it at point where it could be removed and another piece could be inserted, usually within in one day. (Frank Weer.)

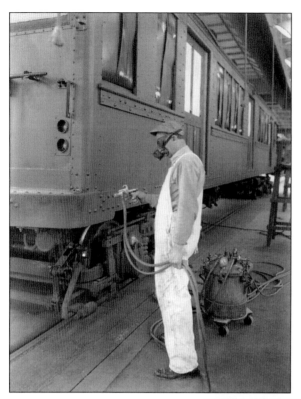

Railroads did in-house craftsmanship jobs such as painting and cleaning railroad cars in the summer months. New technology gave birth to less supervised work sites, and jobs could be completed in less time and by less manpower. One new piece of technology is pictured here. This air-compression driven spray-painting apparatus is used to coat a Market Street El car in the 1940s. (Joel Spivak.)

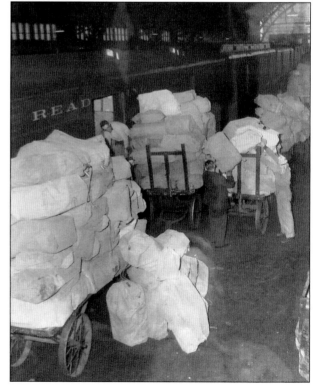

Moving the U.S. Mail farther distances in less time took the form of post offices adjacent to railroad sidings for quick and efficient loading and distribution. New equipment came into use, such as the mail carts, which were ideal for transferring heavy sacks of mail. This was especially helpful during the last week before Christmas at the Thirtieth Street Post Office in West Philadelphia. Mail was also sent across the country by the through trains to Chicago and St. Louis. (Free Library of Philadelphia.)

Working for the railroad during wartime was considered patriotic. When many men went off to World War II, a shortage of workers created opportunities for women to fill in and keep the trains running. The Philadelphia Transit Company of Philadelphia offered women jobs on trains. (Joel Spivak.)

Two generations ago, technology meshed with the railroad industry, and women were a central figure in this updated process. Large switchboards located at the modern Thirtieth Street Station were "manned" by women who took reservations for out-of-state trains over the telephone. (Frank Weer.)

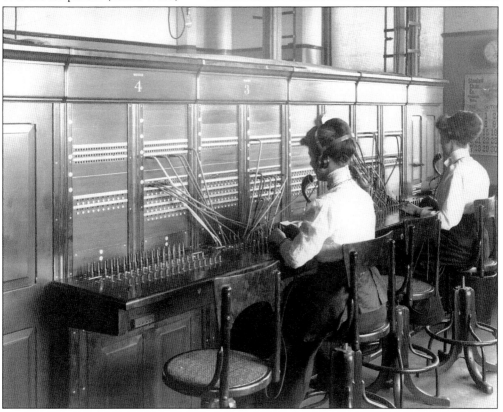

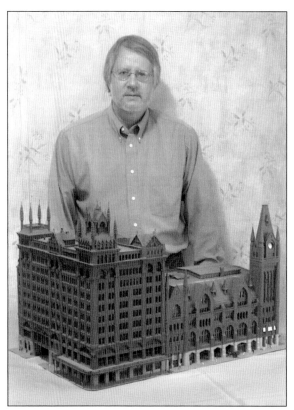

Chuck Denlinger poses with his N gauge, highly detailed model of the Frank Furness Broad Street Station of the Pennsylvania Railroad, which was located across from city hall. The station opened on December 5, 1881. The Philadelphia Orchestra was on site playing "Auld Lang Syne" as the final train pulled away from the station at 10:00 p.m. on daylight savings time on April 27, 1952, to mark the closing ceremony. (Chuck Denlinger.)

This is a rare look inside the Greenwich Hump terminal along the Delaware River, near the U.S. Naval Base. Assistant freight master Earl L. McFarland of Ardmore is at the controls to "switch" railroad boxcars in a train formation according to what cars were released to which private sidings along the Philadelphia Belt Line Railroad (1889). This coupling process is very dangerous, and trainmen sometimes get hurt. (Frank Weer.)

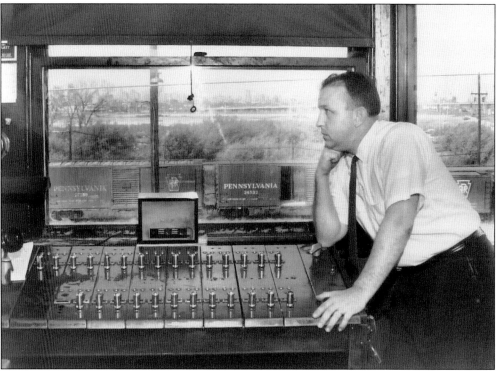

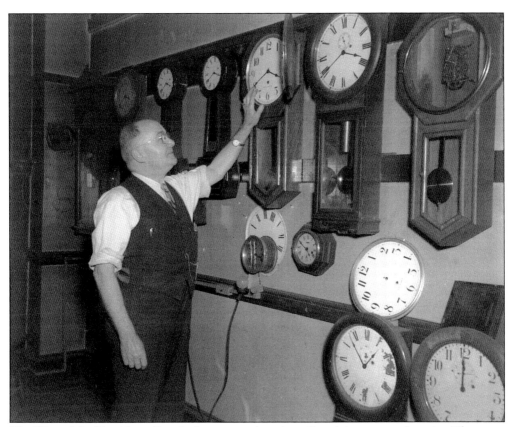

The "Day of the Two Noons" took place to synchronize railroad time across America. The event took place on November 18, 1883. The signal was sent across the United States along telegraph lines. Railroads could now set and publish accurate timetables. (Joel Spivak.)

Army veteran Joel Spivak photographed his friends Richard Bank and Allan Hunter, shown honoring the Reading Railroad veterans, who served in the uniform services of this country during the Spanish-American War, at a late-1890s architectural style corner marker. Since 1994, this ritual is performed every Memorial and Veterans Day, south of the Engleside Branch Railroad (1892) on the corner of Thirty-first Street and Girard Avenue. (Joel Spivak.)

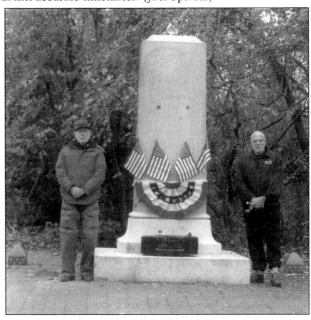

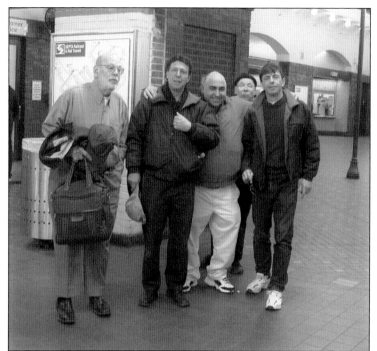

Rail fans gather at the Sixty-ninth Street station to celebrate the 100th anniversary of the Market Street El. Pictured from left to right are Hank Sachs, Harry Pinkser, Russell Greco, Richard Vible, and friend on November 4, 2007. (Joel Spivak.)

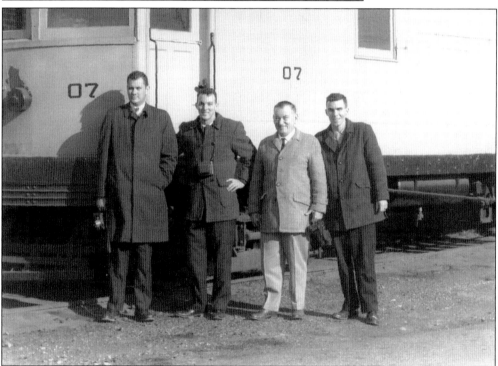

A group of men developed an interest in photographing historical trains in and around Philadelphia. The men gathered the Llanerch Car House on January 26, 1964, to discuss the importance of the Ardmore Junction: (from left to right) Bob Foley, Stan Bowman, Charles Houser, and Andy Maginnis. (Stan Bowman.)

Eight

LOCOMOTIVES

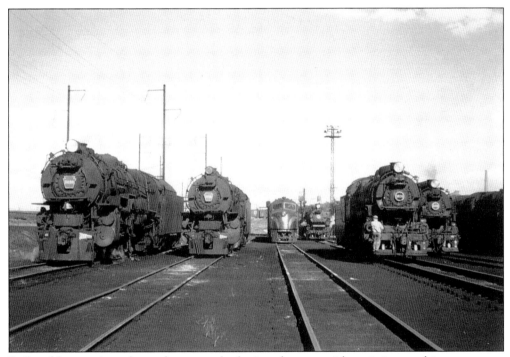

Railroad locomotives changed on a regular basis to keep up with variations and improvements in the technology to operate them. Thousands of locomotives were built in Philadelphia. This photograph was taken near the Municipal Stadium, built for the nation's sesquicentennial (1926), where many steam locomotives brought thousands of fans to Army-Navy football games. Greenwich Yard along the Belt Line Railroad in South Philadelphia is a maze of tracks. (Frank Weer.)

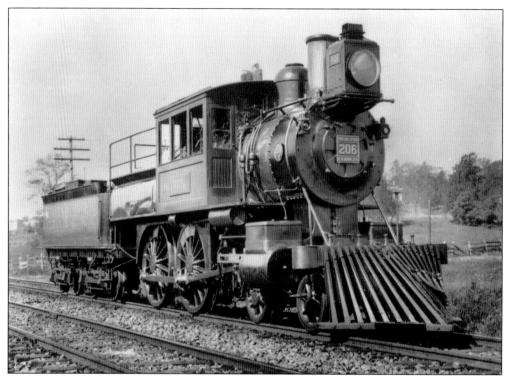

Locomotives developed into racy machines by the late 1880s with the "cattle chaser" bolted to the front of the engine. This camelback locomotive No. 206 made long and short runs, and it broke the speed record with a whopping 90 miles per hour. (Frank Weer.)

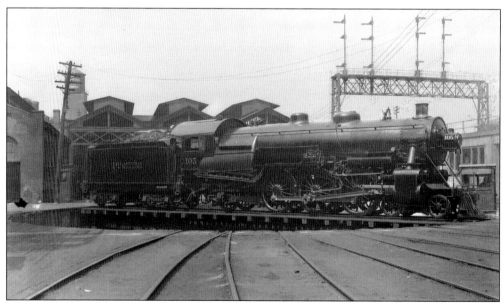

The Ninth and Green Streets engine house, above Spring Garden Street, served the busy Reading Railroad main line to Germantown and Manayunk. The huge turntable could redirect engines from north to south tracks in a matter of minutes with its hydraulic system. (Frank Weer.)

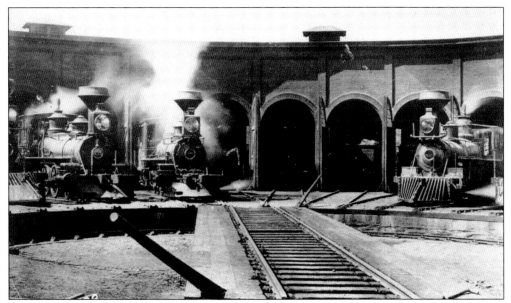

This very rare 1885 photograph was taken from the opposite end of an engine turntable at the North Pennsylvania Railroad's main depot at Third and Berks Streets. Trains came down the middle of American Street after passing Penn Junction and Fairhill Junction. The engine house was one of the largest in Philadelphia and could hold and service more than 16 locomotives. The beautiful smokestacks sat back from the very large headlight that was powered by kerosene fuel. (Ted Xaras.)

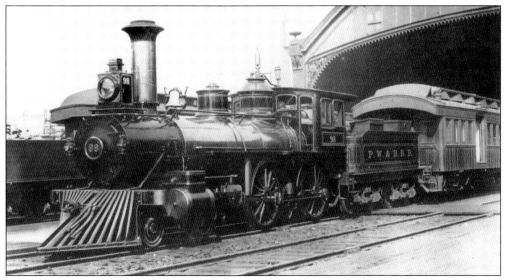

In 1895, a Philadelphia, Wilmington, and Baltimore Railroad locomotive leaves the Broad Street and Washington Avenue station in South Philadelphia for the Gray's Ferry Railroad Bridge on its regular trip through Southwest Philadelphia to points south of Wilmington, Delaware. Each train had a large coal-hopper car filled with anthracite coal to power its journey to pick up more passengers. (Free Library of Philadelphia.)

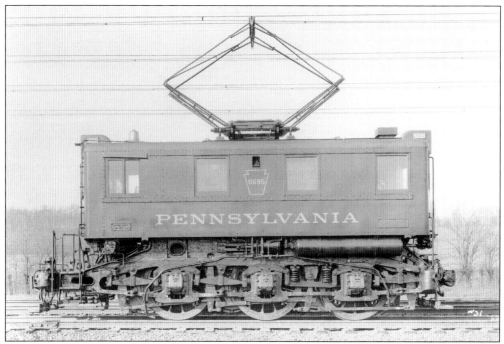

Railroad books are full of locomotives that seem to all appear alike. Philadelphia had the unique pleasure of being an independent creator of engines to meet its rail yard needs. This Pennsylvania switcher, an early electric model with six wheels, ran mostly underground in the Thirtieth Street rail yard. These little workhorses were nicknamed the "rats." (Frank Weer.)

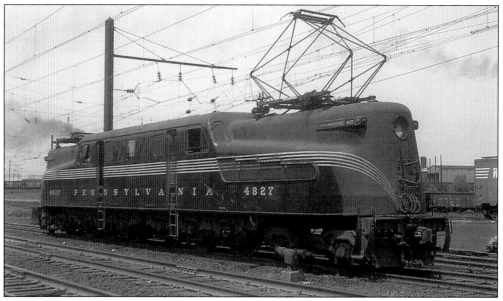

The famous GG1 electric-powered locomotive built by the Pennsylvania Railroad (G1 4-6-0) was only one locomotive. Double-head locomotives (4-6-0 + 0-6-4) were designed to protect schedules. Railroad accidents led to the design with a center cab, plus the distinctive pinstripes. The GG1s were designed by Raymond Loewy in the 1930s and photographed in the north Thirtieth Street rail yard. (Dave Homer.)

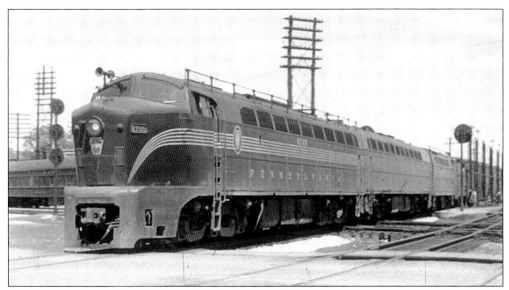

The diesel model in this photograph is called the "shark nose" due to its striking resemblance. This design featured a welded shell, which eliminated tens of thousands of rivets. Locomotives were painted green or red to designate whether they were a passenger or freight locomotive. The aerodynamic features were greatly enhanced to allow the train to reach high speeds of travel. (Dave Homer.)

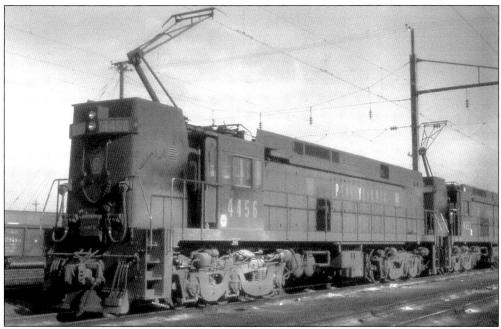

The diesel electric E-44 locomotives were made by General Electric Motors. The typical freight locomotive had a square-front design, which gave the operators a clear line of vision. Operators relied on this important piece of railroad innovation in Philadelphia during the 1960s while traveling along the little-known Stifftown Branch Railroad (1880), with its many industrial sidings. Stifftown Branch Railroad was located in North Philadelphia at Ninetieth and Indiana Streets. (Dave Homer.)

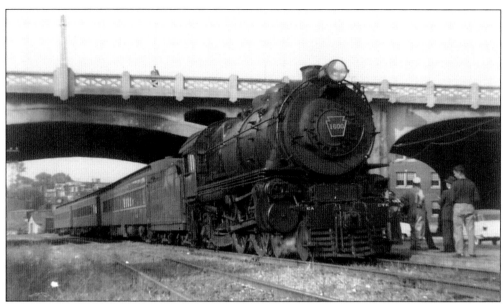

After close to 150 years of service along the Schuylkill Valley Branch Railroad (1883), which was acquired by the Pennsylvania Railroad, the last passenger train pulls out of Reading on October 4, 1953, embarking on its final journey to Philadelphia. Freight service continued for the next 30 years until its tracks were removed and paved over for the Valley Forge to Philadelphia bike trail in the late 1980s. (Stan Bowman.)

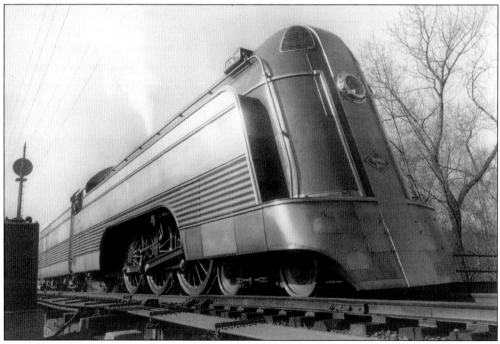

Sleek new trains came on line in the 1930s as the country began to view railcars and their design as high adventure. Locomotives needed to become more streamlined in order to compete with the commercial airplane industry. The Reading Railroad had the Crusader pictured above. (Frank Weer.)

The old MU, or multiple-unit, car is shown here with its expanding pantograph (the arm used to pick up the electric current to power the train). The MU cars were built by the Bethlehem Steel Company in 1931 and ran until the mid-1980s. (Frank Weer.)

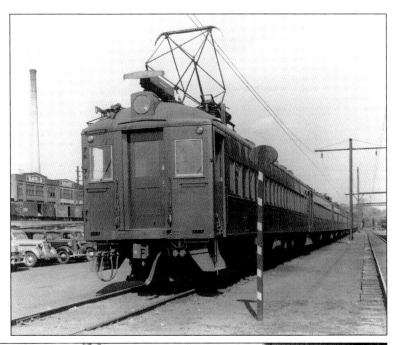

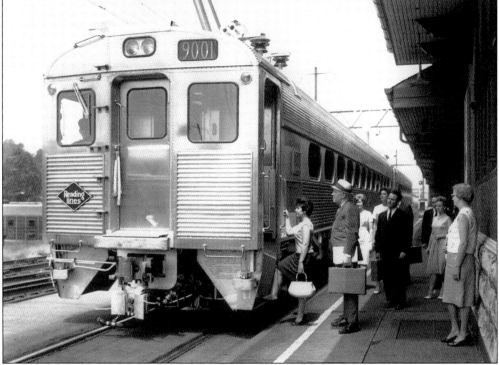

The Budd Company built 17 Silverliners in 1960 for the Reading commuter lines. The diesel railcars ran from Fox Chase station to Newtown. The City of Philadelphia contributed to the cost of the electrification of the Fox Chase Line, but Bucks County did not want to bear any costs for doing the same on the line north from Fox Chase to Newtown. Riders had to get off at Fox Chase and transfer to the diesel railcars, which ceased operation in the early 1980s. (Frank Weer.)

A unique piece of history is parked on the east side of Broad Street, along Noble Street. Dining car No. 1186 sits on the north side of the 401 North Broad Street commerce building, a modern terminal and warehouse. The Dining Car Restaurant is set to reopen in 2010 on a siding where the passenger trains ran over the north Thirteenth Street Bridge to the Reading Viaduct. (Allen Meyers and Joel Spivak.)

The red caboose is a part of the American railroad landscape that is no longer in use. The caboose provided a high platform for trainmen to observe the condition of the track ahead. It also housed sleeping quarters for the weary railroad crews, and a kerosene lantern was hung on the rear of the caboose at night to give warning to any approaching trains. A preserved "Bobbie" is located in Blackwood, New Jersey, off Blackwood-Clementon Road, north of Black Horse Pike. (Frank Weer.)

Nine

RAPID TRANSIT LINES

The saga of Philadelphia's rapid transit plans dates back to the 1870s. The concept of a subway system and elevated railways followed a movement to divert rail traffic under or above the living spaces of the masses. The Keystone Railroad Company (1879), the Metropolitan Railroad Company (1886), the Broad Street Railroad Company (1889), the Quaker City Elevated Railroad Company (1892), and the Philadelphia city plan "Dream Metropolis" (1911) all submitted plans. Seeking to connect America with interurban railcars, the Philadelphia and Western Railroad turned into a third-rail operation to Stratford and north to Norristown, where the Lehigh Valley Transit Authority ran the Liberty Liners to Allentown. When Philadelphia became connected to Camden, New Jersey, via the Delaware River Bridge, railroad tracks and a proposed trolley line stretched across the bridge to two stops in Camden. (Joel Spivak.)

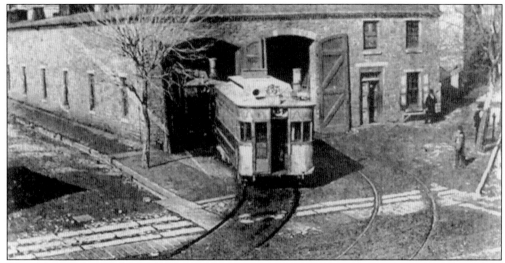

The replacement of the horse-drawn omnibus and street railway cars became a dream of Philadelphia's industrial men during the height of the Civil War. Coming out of the car barn at Arrott and Frankford Avenue are the two-cylinder, coal-powered vehicles named *Alpha* and *Seagull*, which were also called steam dummies. This modern form of transportation lasted until the 1890s, and some ran on Market Street in West Philadelphia from Thirty-second Street to Sixty-third Street. Another line ran from Forty-first Street and Haverford Avenue to Sixty-third Street. (Frankford Historical Society.)

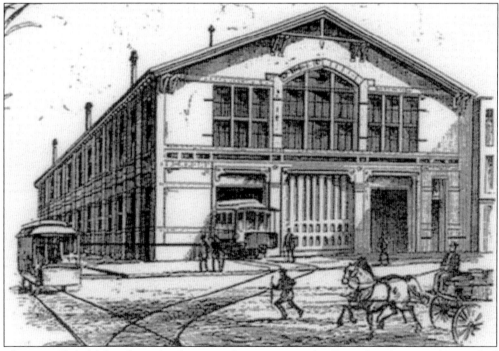

The West Philadelphia depot for the steam dummies existed at Forty-first Street and Haverford Avenue. The steam dummies lasted on Market Street until America's centennial and Industrial World Exhibition, which was less than 4 miles into Fairmount Park from the West Philadelphia Station at Thirty-second and Market Streets. (Free Library of Philadelphia.)

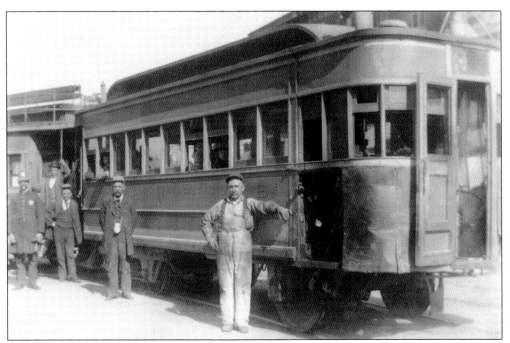

The northern section of Philadelphia needed additional transportation lines to connect small villages to one another. The North Pennsylvania Railroad (1852) ran down American Street to its depot at Fourth and Berks Streets. The Frankford Line of the steam dummies picked up and dropped off passengers on trips to its turnaround at Arrott Street and Frankford Avenue. Operation of the steam dummies was suspended in 1892 with the arrival of the electric streetcars. (Library Company of Philadelphia.)

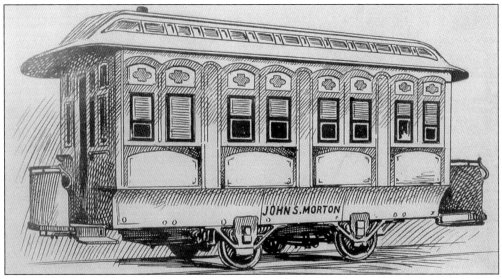

The sturdy steam dummies ran in poor weather conditions on the Market Street Line. These cars were the forerunners of the subway and elevated cars with a clerestory roof (containing light holes) and the center door in the rear of the car. The steam dummy cars and cable cars (1873) became more popular after the deadly horse disease epidemic of 1873, which claimed 2,500 horses in Philadelphia. (Joel Spivak.)

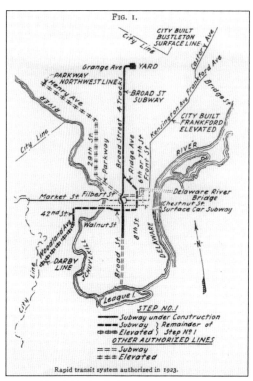

This 1923 map of the transit report was created by Henry E. Ehlers, director of the City of Philadelphia. Prior to World War I, Philadelphia had plans to transverse the city by 10 subway and elevated lines that included the following: Woodland Avenue, Passyunk Avenue, Third Street, Broad Street (north and south), Market Street, Delaware Avenue, Twenty-ninth Street, Henry Avenue, Germantown Avenue, and Northeast (Roosevelt) Boulevard. (Joel Spivak.)

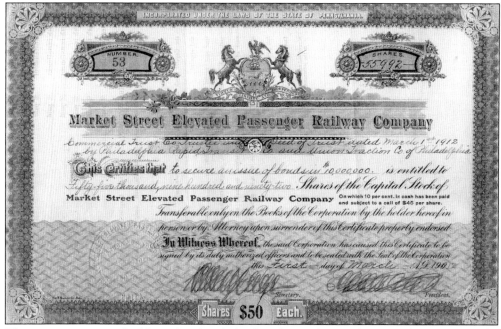

The steps necessary to build a railroad include identifying where to locate and run it. Next the parties involved must petition the state for a charter giving them a legal right to form a company. Fund-raising through subscription to the idea is then put into action by selling stocks. They are sold in increments of $50 each until enough capital is raised to buy land and survey the right-of-way. The prescribed time to start construction is within seven years. (Joel Spivak.)

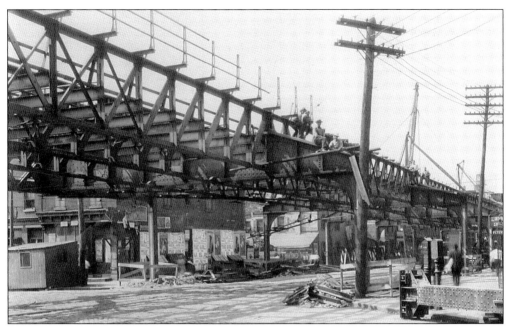

Construction of the Market Street El began on October 17, 1904. This photograph, taken at Fifty-sixth Street, shows the steel skeleton made up of the Pratt and Warren Truss System, supported by steel columns sunk into the sides of Market Street. (Philadelphia City Archives.)

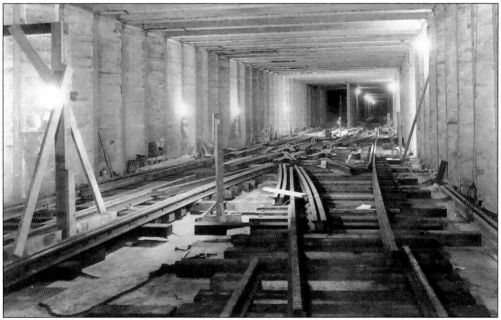

The age of reinforced concrete arrived in Philadelphia during the 1850s, and the Market Street El and Subway from West Philadelphia to Downtown Philadelphia used concrete extensively in the tunnels of the subway once they were supported with heavy timbers and iron girders. This photograph is a crossover before the Fifteenth and Sixteenth Street station. This is where the subway ended in 1907 until more construction was done the following year to get around the city hall complex. (Bill Thomas.)

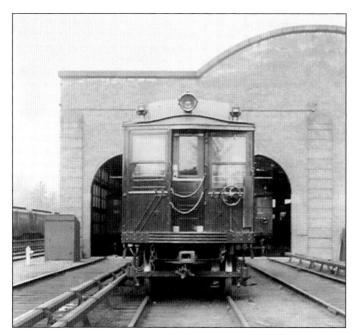

The first trains were built by the Pressed Steel Company of Pittsburgh in 1906 and delivered by the Pennsylvania Railroad on a track adjacent to the Sixty-ninth Street car shops. The cars lasted in operation until 1962. A fact that is rarely, if at all, mentioned is that the current Melbourne station, named for the borough outside of Philadelphia, was called Sixty-sixth Street station until 1920. The Sixty-sixth Street station opened in 1908 as a flag stop station for many years. (Joel Spivak.)

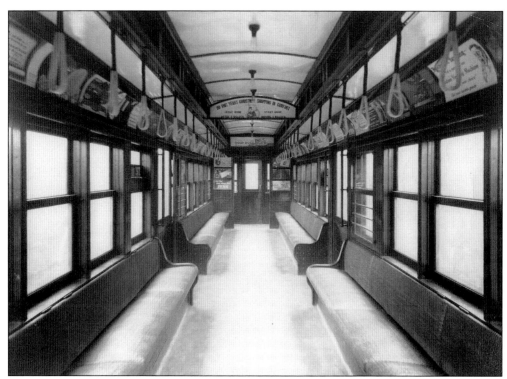

The designation of M-1 for the first cars stuck as the years went on and other railway cars came into operation at a later time. The Market Street cars had the honor of being the first design to incorporate the easy-access feature of a third door in the middle of the long railroad car. (Bill Thomas.)

The new transportation center for the Market Street El, located in Upper Darby, existed outside of Philadelphia. The end-of-the-line station, designed by R. C. Heath and opened in 1907, served as a hub for connections to outlying areas in nearby suburbs of Delaware and Montgomery Counties. (Bill Thomas.)

Tickets for rides on the Market Street Elevated Passenger Railway Company were initially purchased, similar to railroad tickets. E. E. Baxter and his friend W. P. Carpenter of 2256 South Seventh Street bought the first El tickets from agent Agnes Hess in Upper Darby on March 4, 1907. (Joel Spivak.)

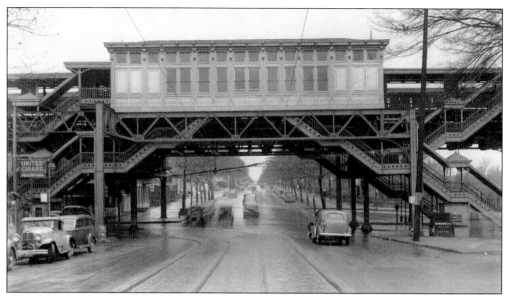

The Sixty-third Street station along the Market Street El became an example of the power and strength the riding public could expect in the coming years of the early 20th century. This station spread out to encompass the full intersection, with access to the West Chester Trolley Railroad (1896) also at this terminal. (Bill Thomas.)

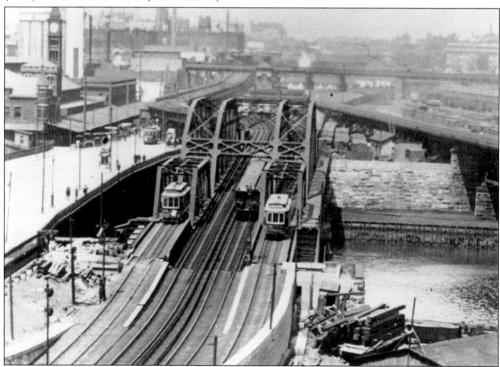

Initially the Market Street El shared a bridge over the Schuylkill River with the various West Philadelphia trolley lines and ran in the center. During the 1930s, a tunnel under the river was built as part of the Philadelphia city plan of transit improvement, but funds ran out and the project had to wait until the end of World War II to resume. (Andy Maginnis.)

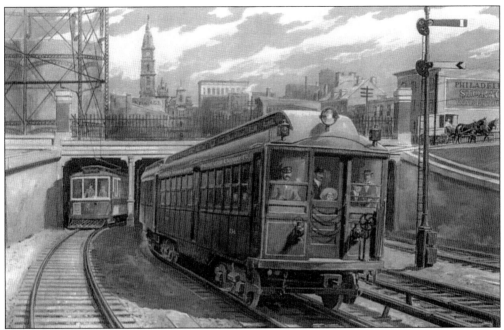

The Subway-Surface cars partially ran on railroad tracks and served the downtown department stores with access from West Philadelphia along trolley car routes No. 10, 11, 13, 34, and 36 and interurban No. 37. Intercity route No. 37 traveled to Chester via railroad tracks and trolley tracks, which intersected the Thirty-second Street Trolley switching tower and junction and then crossed the Market Street Bridge to the Twenty-third Street portal of the subway. (Joel Spivak.)

Philadelphia's first subway station, located at Nineteenth and Market Streets, served the Subway-Surface cars from West Philadelphia. The outer tracks of the subway provided local stops for the trolleys. The handsome architecture reflected an American approach to subterranean public space. (Bill Thomas.)

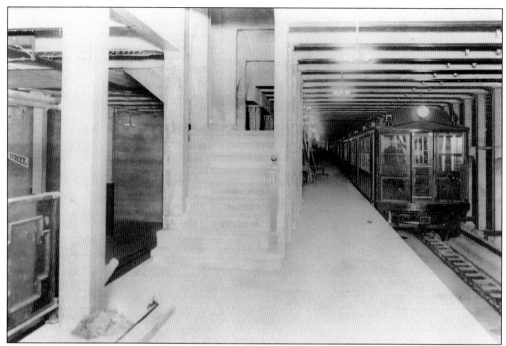

Reinforced-concrete columns appeared in all aspects of the subway's construction. For the first Market Street El station at Fifteenth Street, its entire environment underground made use of this highly durable concrete. Note the concrete platforms, the rail bed set over a concrete drainage system, and the half-cut railroad ties to secure the concrete tracks. (Bill Thomas.)

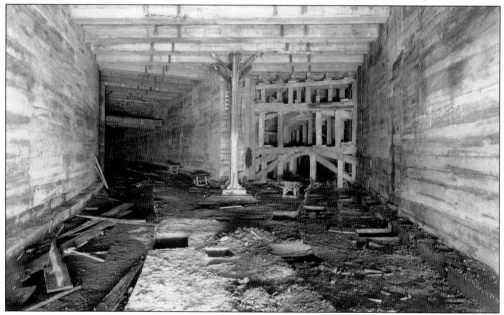

The underground construction done around Philadelphia's city hall posed a special problem: The tunnel had to curve in order to find the east side of Market Street. The original tunnel went around city hall into two tunnels—one for the Market Street El and one for the Subway-Surface cars. The wooden scaffolding allowed workers to expand the tunnel safely. (Bill Thomas.)

The East Market Street Subway created a large open hole from city hall down to Second Street. The workmen were always weary of the continuous parade of packed trolley cars above their work areas. The subway made a turn northward at Second Street to Arch Street where a portal to the Delaware Avenue El extended nine blocks to the South Street ferry terminal. (Richard Vible.)

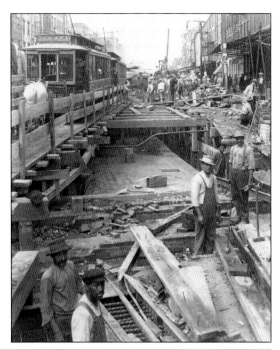

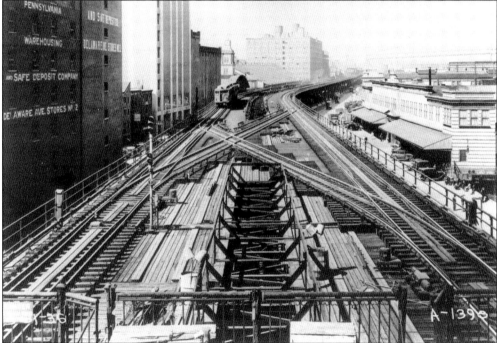

Patrons of early public transportation from nearby suburban communities could get into Downtown Philadelphia or head for the Atlantic City seashore in the summer via one line. The huge aboveground construction project (1907) to bring the El close to the ferry ports was known as the Ferry Line, which ended on Delaware Avenue at South Street. The large distance between tracks was built over Delaware Avenue's maze of steam locomotive lines that served the municipal piers and wharves. (Andy Maginnis.)

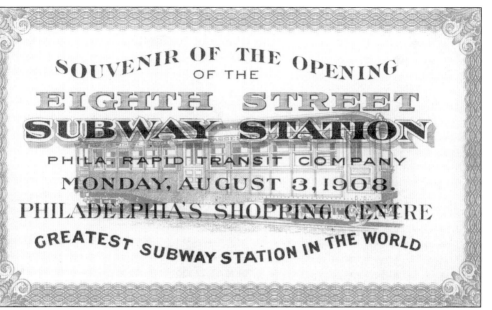

SOUVENIR OF THE OPENING

OF THE

EIGHTH STREET

SUBWAY STATION

PHILA. RAPID TRANSIT COMPANY

MONDAY, AUGUST 3, 1908.

PHILADELPHIA'S SHOPPING CENTRE

GREATEST SUBWAY STATION IN THE WORLD

The opening of the East Market Street Subway to Eighth and Market Streets was preceded in July 1908 by a public banquet, which was like none other in the city. Future patrons munched on 10,000 sandwiches, 2,000 sweetbread cutlets, 80-dozen smoked-beef tongue, and 3,500 chicken croquettes and washed it down with 200 gallons of coffee and 50 gallons of tea. The men settled back on the chairs at the Strawbridge and Clothier department store platform and smoked 100 boxes of cigars. (Joel Spivak.)

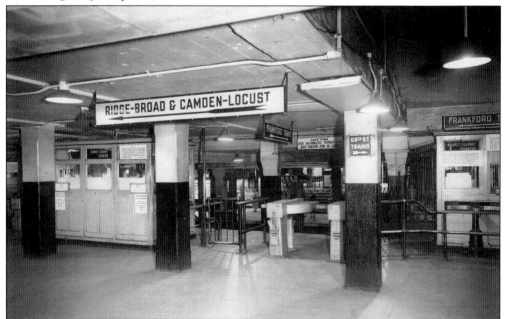

The plan to build multiple subways in Philadelphia yielded the Ridge-Broad Line, via a connection to Eighth and Market Streets. Opened in 1932, this line connected with the Camden-Locust Line. The Ridge Avenue spur stopped at Vine and Spring Garden Streets just before Broad Street at the Fairmount station and ended at Broad Street and Girard Avenue. (Joel Spivak.)

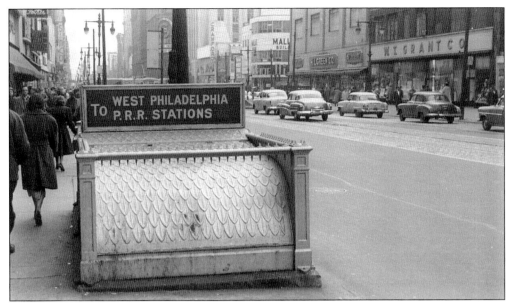

Access to the Market Street Subway system from the famed Department Store Row on the north or south side of Market Street attracted people from all over the Delaware Valley, especially at Christmas. To get home in West Philadelphia after shopping at Wanamaker's, Strawbridge and Clothier, Gimbel Brothers, and Lit Brothers department stores meant descending a flight of granite steps off the wide pavement of the downtown district into the subway. (Joel Spivak.)

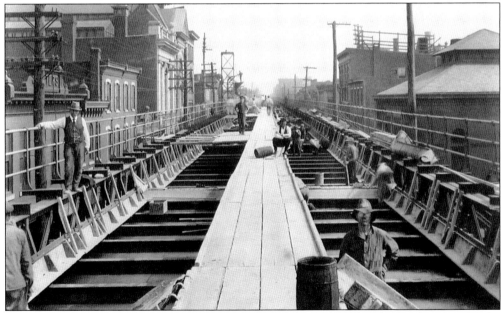

After World War I, the plans to move forward with construction of the El to Bridge Street in the northeast section of Philadelphia known as Frankford got underway in 1918. The connection of the northeast with downtown competed with the established steam locomotive railroads. The third-rail electric technology made for a fast ride downtown. The 75-year-old complaint of running a train down Front Street, which led to riots, was no more. The City of Philadelphia built this line! (Philadelphia City Archives.)

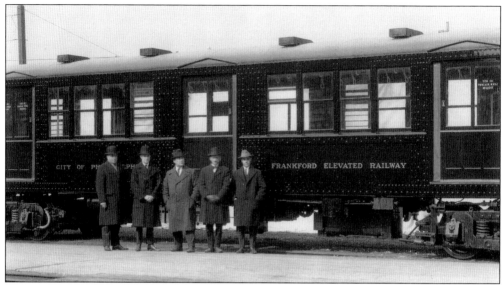

The new cars for the Frankford Line arrived from the J. G. Brill Company trolley and train works in Philadelphia in 1922. Philadelphia owned the new Frankford Line, as it envisioned more residents living in the Northeast after World War I. This extension of the Market Street Line interconnected above Arch Street on its journey to Bridge Street. The two elevated systems acquired in 1923 by the city became known as the Market-Frankford Elevated Line. Many folks just call it the El. (Joel Spivak.)

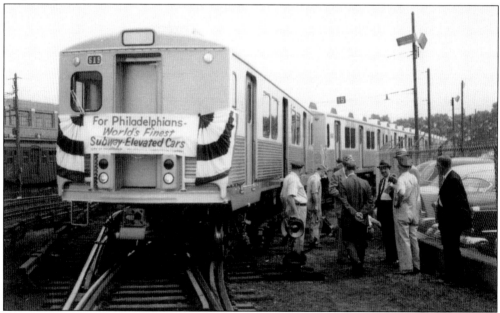

A third version of trains came on line in July 1960 with the arrival of the new stainless steel cars, which were manufactured in Philadelphia by the Budd Company. Farther out in the northeast, on Red Lion Road, the train division of Budd made 270 cars with ventilation systems on each car. The vents on top made them reminiscent of the Almond Joy candy bar, which is how they got the nickname "Almond Joy." As the new equipment went into use and the old cars were phased out, the ride downtown became quieter and less bumpy. (Bill Thomas.)

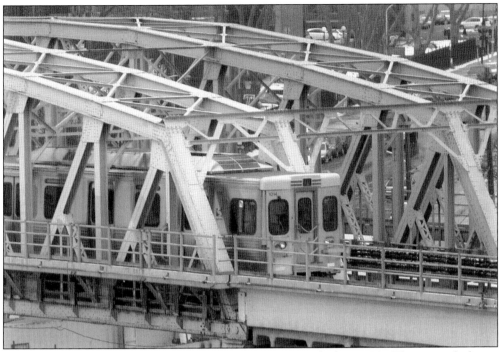

The fourth generation of elevated cars came on the scene in the late 1990s. These new sleek cars have real air-conditioning but smaller seats. The designation of M-4 is shorthand for the next generation of cars. The new cars shoot over the long double truss bridge traveling toward the El, over the Richmond Branch Railroad of the Reading Lines. (Joel Spivak.)

The age of the El between Market Street and Frankford necessitated many repairs to maintain its safety. Federal funds from the Mass Transit Fund were acquired to rebuild the El. Allen Meyers, longtime management person with McDonald's Restaurants, sat on the Frankford Business and Professional Association (1994–1997), which had a major role in deciding the alignment and plans for the new Frankford Transportation Center that opened in 2003. (Joel Spivak.)

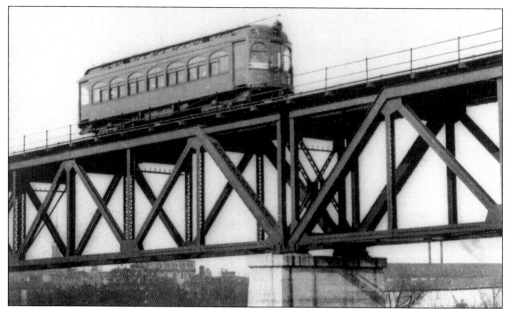

With major setbacks, the Philadelphia and Western Company, also known locally as the "Pig and Whistle," streamlined its operation as a regional railroad. First, the best idea was to have the entire right-of-way powered by a third-rail electric power system. Next, the company planned a branch from Villanova to travel northeasterly into Norristown (1912), the county seat of Montgomery County, over the Schuylkill River Bridge. A later link with the Lehigh Valley Transit Authority filled the dream when Allentown and the Liberty Liner service began on a daily basis. (Bob Foley.)

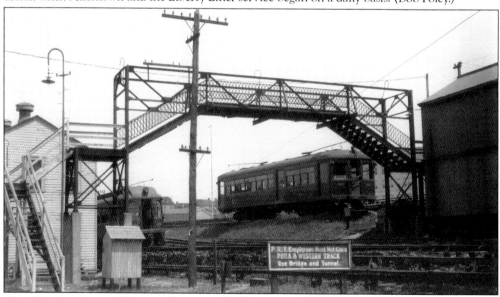

The Philadelphia and Western Company (1907) was conceived as part of a grand plan to unite the East and West Coasts via heavy-duty interurban vehicles on railroads. The Philadelphia link would go to York, Pennsylvania, south of Harrisburg, and even sought an alternative route downtown from Sixty-ninth Street; however, the company settled for a short route from Stratford in 1907. The Stratford cars were all steel and built by the nearby J. G. Brill Company in the 1920s to bolster its roster of vehicles. (Bob Foley.)

The new cars for the Norristown Line, along with its pretty scenery in all seasons and great right-of-way, allowed for the company and its successor to think about speed from point A to point B. The all-aluminum, Brill-built "Bullet Cars" could go 100 miles per hour. These cars were accident free from 1931 to 1991 and were the first cars tested in a wind tunnel. (Bob Foley.)

The Liberty Liners were made up of four coaches and a lounge car and had a bar speed through the countryside, delivering passengers and packages in record time. The vehicles were built by the St. Louis Company in 1941 for the North Shore Line in Chicago. Trains acquired by the Red Arrow division of transit in the western suburbs used these on what became known as the Route 100 Line from 1963 to 1979. (Bill Thomas.)

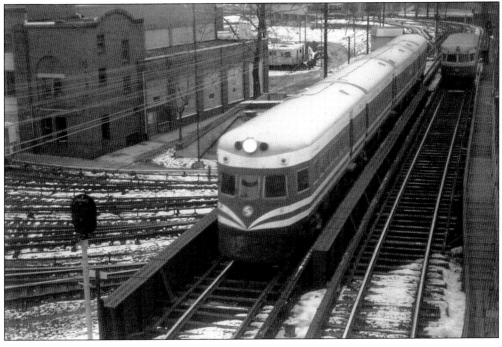

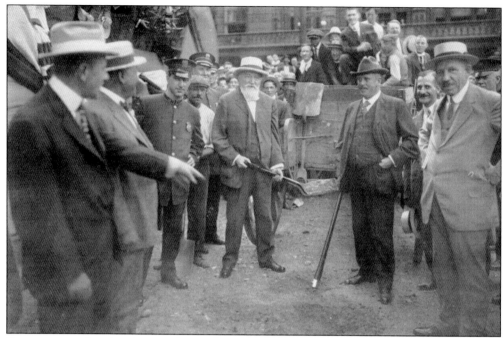

Twenty years after the plans to dig a subway were floated in Philadelphia, ground was broken near city hall for the first leg of the North Broad Street Subway. Mayor Rudolph Blankenburg (with shovel) and Merritt Taylor, director of the Philadelphia Rapid Transit Company (with pick), joined in the ceremony on September 11, 1915. The subway project came to a halt as World War I began and did not resume until 1923. (Bill Thomas.)

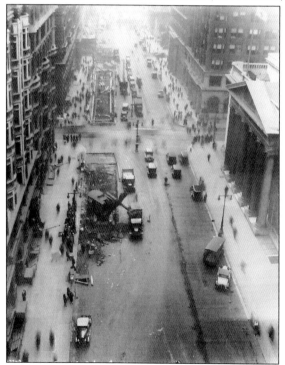

The portion of the Broad Street Subway south of city hall broke ground near Chestnut Street in 1926. The South Broad Street Line would go only as far as Walnut Street. Portions of the subway were planned to go onto an elevated platform north of Norris Street, but members of the upper class who objected the decreased property value near Temple University if that occurred and therefore soundly rejected those plans. (Bob Thomas.)

The Keystone Construction Company oversaw the building of the Broad Street Subway. Large steel girder beams were required to support the Market Street Subway over the Broad Street Subway. Workers posed on the gigantic beams being installed in the 1920s. (Philadelphia City Archives.)

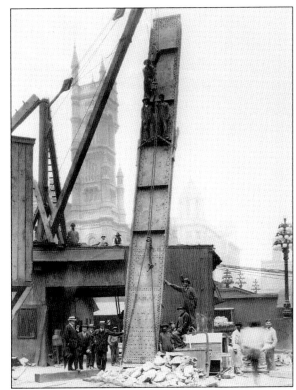

The steel beams to support the street over the subway are really prominent in this rare photograph showing the extent of the project on the northwest corner of city hall, where Broad Street rounded into Market Street going west to the Schuylkill River. Hundreds of trolley cars that circled Philadelphia's tallest landmark at the time had to be diverted in all directions, which made for a continuous line stretching all the way onto East Market Street to the loop at Front Street. (Philadelphia City Archives.)

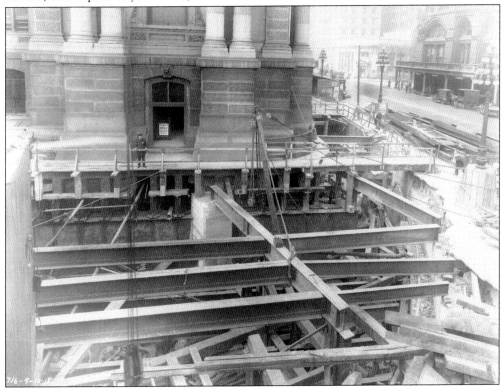

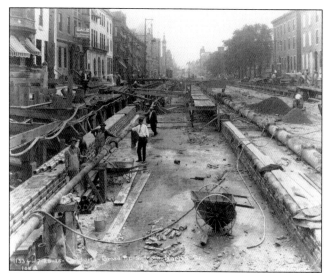

The Broad and Norris Streets section of the North Broad Street Subway took up the entire street and left little room for pedestrian traffic. There is a hump on North Broad Street toward Lehigh Avenue where the road is elevated so the subway has enough clearance in the vicinity of the regional railroad lines. (Bill Thomas.)

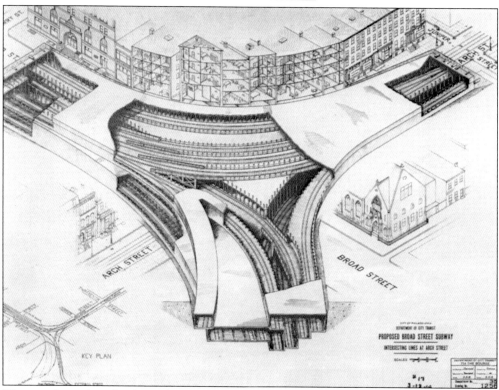

The grandiose plans for the underground transit system in Philadelphia, which was thought to be second to New York City, had some very interesting futuristic plans before the concept of highways were even considered. This cutaway section actively integrated the North Broad Street Subway below Arch Street, near the famous Masonic Hall (lower left). The Filbert and Walnut Streets Center City Delivery Loop was equal to the famed "Chicago Loop," only it would run underground (to the right side). The top part of the junction was reserved for the Arch Street Subway to the Parkway and then up Twenty-ninth Street as an elevated line to Roxborough, via Henry Avenue. (Bill Thomas.)

The southeast corner of Broad Street and Girard Avenue held many memories for thousands of Philadelphians. The Widener Mansion, Majestic Hotel, and other magnificent halls for weddings and affairs were now reachable by the Broad Street Subway. Even the participants in the Mummers' Parade on New Year's Day accessed the subway for the trip home. But some residents refused to use the subway due to fears "of entering the Under World." For those customers, a ride on the Broad Street C bus was a better alternative. (Joel Spivak.)

Schoolchildren rode the subway on their way to Central High School, Girl's High School, Old Northeast High School, and Murrell Dobbins Career and Technical Education High School. The fast and express token-driven turnstiles, especially at Broad Street and Olney Avenue, sped everyone on their way. Tokens and transfers were sold at the cashier booth to access the Logan stop, originally named the Lindley-Ruscomb Street stop. (Joe Boscia.)

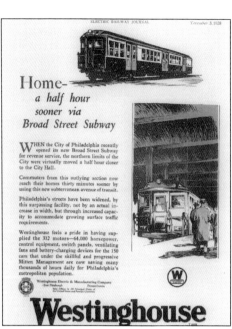

The North Broad Street Subway from city hall to Olney (5600 North Broad Street) opened on September 1, 1928. The cost of $90 million for the 11.5-mile-long system was huge in those days. Some stops were identified by two streets, such as Susquehanna-Dauphin, where the street level could be accessed at either location. Temple University, an urban educational institution of higher learning, was reachable along this route, as well as the two baseball stadiums along Lehigh Avenue—Baker's Bowl (1939) and Shibe Park (1909), later known as Connie Mack Stadium. (Dennis Szabo.)

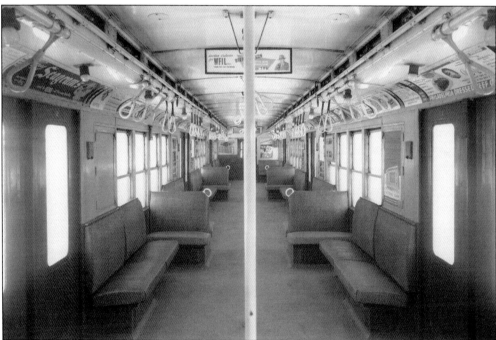

The interior of the original Broad Street Subway car had progressed from that of other passenger cars only 20 years prior. Large crowds and a car filled to capacity with 70 people either sitting, standing, or holding onto the invention of the subway straps all made for a fun and unusual ride every trip. Advertisements for products adorned the curved portion of the car with "car cards." Paper goods were not known at this time, and the floors always remained clean and free of debris. One curious element that is rarely talked about is the big spittoons (gigantic brass vases) that were placed on the subway platforms into the 1960s as receptacles for people who chewed tobacco. (Bill Thomas.)

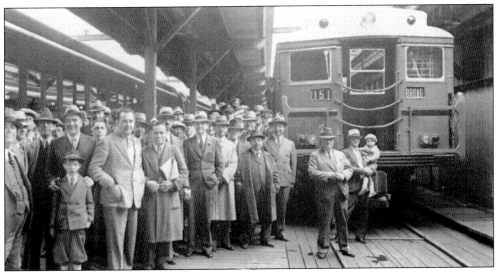

The progress in building a mass transit system in Philadelphia is great to see unfold. Even though the Great Depression hit Philadelphia hard with the loss of industrial jobs, the Broad Street Subway, opened in 1938, extended to Synder Avenue in South Philadelphia near St. Agnes Hospital. A tunnel portal built into the subway on the west side of Broad Street for the future Passyunk Avenue Subway is just an indentation today. More rolling stock was needed, and pressed steel cars were on display at the then-new North Philadelphia Station. (Bill Thomas.)

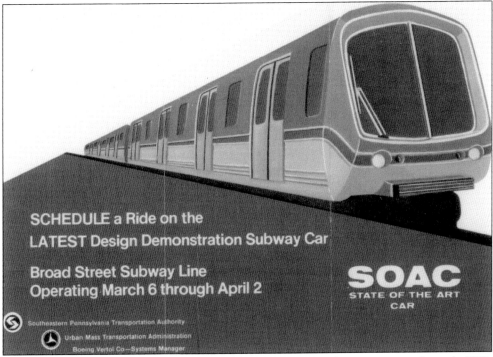

The SOAC, otherwise known as the State of the Art Car, gained momentum in the early 1970s with the help of the St. Louis Car Division of General Steel industries and U.S. Department of Transportation. They built and sent cars to major railroad centers around the United States to inspire new rapid transit systems. (Bill Thomas.)

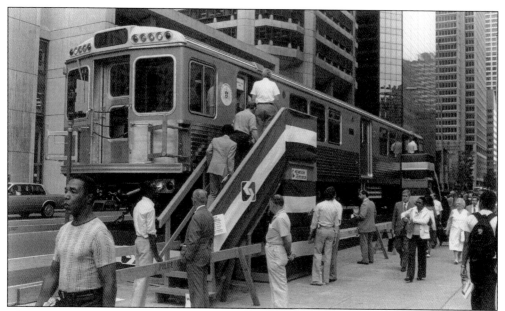

The need for new subway cars is due to the daily wear and tear on the equipment. The riding public loves to see the upgrades, too. This time not only did Philadelphia get a new ride, the name was changed as well. The Broad Street Subway Line now became the Orange Line. The new cars were unveiled above ground to the public at Fifteenth and Market Streets in 1983 by the Southeastern Transportation Authority (SEPTA). (*South Street Starr Paper*, Nick D' Quanno.)

The continuous integration of the mass transportation system since SEPTA took over is evident in the construction and completion of the new Fern Rock Transportation Center. While the regional rail lines of the former Reading Railroad underwent major infrastructure replacements in the early 1990s, people from the northern suburbs were temporarily forced to transfer at the Broad Street train storage facility and then take the Broad Street Subway that would take them to Downtown Philadelphia. The temporary setup went so well a new permanent center was built with access to subway, bus, and regional rail lines. (Joel Spivak.)

Flash Gordon Cars? No, just the new streamlined look of self-propelled train architecture in the 1930s, which was built, yet again, by the J. G. Brill Company of Philadelphia. The cars for the Bridge Line ran along the outer railing of the Benjamin Franklin Bridge. This line had two stops in Camden, New Jersey, one at city hall and the other at Broadway, and two stops in Philadelphia, one at Seventh and Race Streets and the other at Eighth and Market Streets. Opened in June 1936, the Bridge Line expanded during the 1950s "rail renaissance" and was extended to Sixteenth and Locust Streets in February 1952. Today the Port Authority Transit Corporation (PATCO) Line (1968) connects with the recently opened the River Line from Camden to Trenton. (Free Library of Philadelphia.)

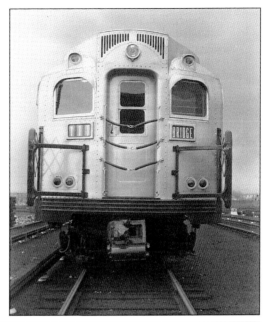

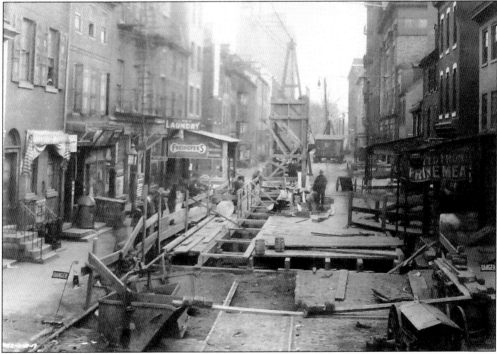

The opening of Philadelphia's streets is nothing new. This is the 900 block of Locust Street under construction in 1917. Stopped because of World War I, construction was finally completed in 1931. Again, due to unexpected events, such as lack of funding during the Great Depression and World War II, it did not become used until the city planners thought it best to connect the Locust Street Subway to Eighth Street, which was originally planned in October 1952. The PATCO Line made use of the Locust Street Subway and connected to it as a through line to New Jersey in 1968. (Philadelphia City Archives.)

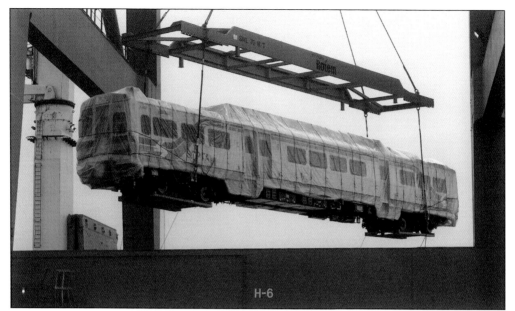

H-6

Change is again on the march in the annals of Philadelphia's never-ending railroad history. In March 2010, SEPTA received a shipment of the new Silverliner V cars from South Korea's Hyundai plant in Changwon. Nine shells, complete with SEPTA logos and paint schemes, were unloaded at the now-abbreviated Swanson Street Railroad (1874) yard in South Philadelphia under the Walt Whitman Bridge. Here the assembly process of the new cars was completed, and the public was introduced to the cars in April 2010. With the arrival of the new cars, SEPTA decided to scrap the R designation system, which was created by Vukan Vuchic of the University of Pennsylvania; however, this decision was never fully implemented, and a return to original rail line names were implemented again in June 2010. (Andy Andrijiwsky.)

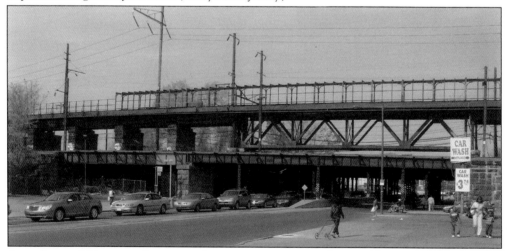

A modern multi-integrated system and transportation center that would serve the communities of Parkside, Wynnefield, Overbrook, and West Philadelphia will hopefully one day be located at Fifty-second Street and Lancaster Avenue. The location of this possible hub had its beginnings more than 175 years ago with the creation of the West Philadelphia Railroad, which was developed to avert the Belmont Plane. To harness the potential of a super hub, all that is necessary is the will to connect the dots at this historic intersection. (Allen Meyers and Joel Spivak.)

126

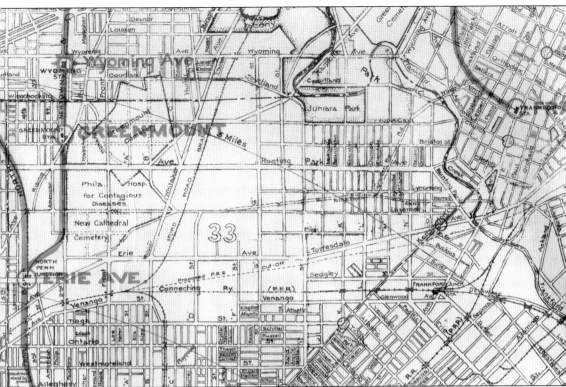

The large industrial wasteland filled with abandoned railroad right-of-ways is a perfect location to showcase that "Philadelphia is truly a City of Firsts." While researching this book, Allen took Joel's love for industrial archaeology to a new level and reversed roles. Exploration of these former railroad right-of-ways in preparation for this book led Allen to think of the possibilities to reclaim the land above Venango Avenue north to Wyoming Avenue and from Fifth Street east to N Street as the boundaries for this new town center. This project could feature a premier American shopping mall, hotels, luxury apartments, condos, the movement of the Philadelphia Zoo to larger quarters, and a theme park like Disney World, all which will stimulate Philadelphia for years to come. This urban plan interfaces modern transportation and American institutions and would serve as a world-class exhibition to urban planning and redevelopment. The new station would be situated along the current Northeast Corridor Railroad, connecting Washington to Boston, with a station built over the tracks. A proposed light-rail trolley line could intersect this station and be developed on American Street situated along an abandoned right-of-way from the North Pennsylvania Railroad (1851), connecting the Penn Junction–Railroad Renaissance Town Center with the proposed SugarHouse Casino along Delaware Avenue and the downtown Market Street East Corridor. The former route No. 56 trolley car could be reactivated on Erie Avenue from Broad Street (subway) running west-east to the Frankford El at Kensington Avenue. The central address of this vision would commence along the old proposed right-of-way of the Pennsylvania Railroad above Erie Avenue near Whitaker Avenue, found on the 1928 Reading Railroad map. Just imagine the community of the future! You may contact Allen Meyers at ameye6@aol.com and Joel Spivak at joelspivak@comcast.net. (Frank Weer.)

DISCOVER THOUSANDS OF LOCAL HISTORY BOOKS FEATURING MILLIONS OF VINTAGE IMAGES

Arcadia Publishing, the leading local history publisher in the United States, is committed to making history accessible and meaningful through publishing books that celebrate and preserve the heritage of America's people and places.

Find more books like this at
www.arcadiapublishing.com

Search for your hometown history, your old stomping grounds, and even your favorite sports team.